IMAGES
of America

COLUMBIA

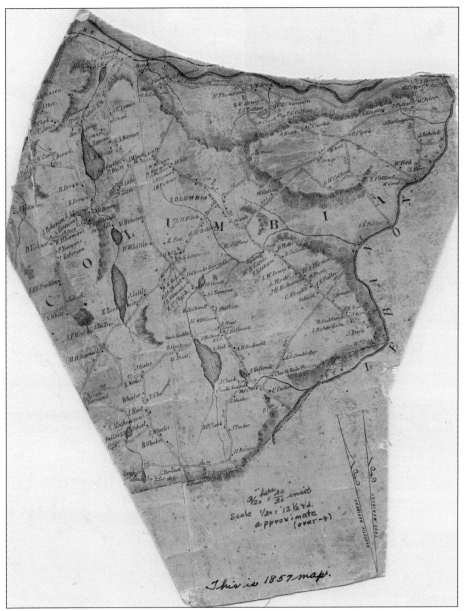

Scale 1/20 : 13 ½ rd. approximate (over→)

This is 1857 map.

MAP OF COLUMBIA. This 1857 map of Columbia, from the *Atlas of Tolland County* published by Woodford and Bartlett of Philadelphia, shows topographic features, roads, mills, the Hop River Manufacturing Company, the New York & New England Railroad, property owners, and an elm tree on West Street that was 40 feet in circumference. Note the original pond and land area that was dammed in 1865 to create a reservoir, now Columbia Lake. (CHS.)

ON THE COVER: CAMP ASTO WAMAH. Virtues of patriotism, reverence, friendship, and loyalty were instilled in boys and girls at Connecticut's oldest continuously operating camp. Established by the Center Church of Hartford with the help of Columbia resident Evan Kullgren, Camp Asto Wamah, meaning "clear water," has been located on Columbia Lake since 1910. (Courtesy N. Mclean.)

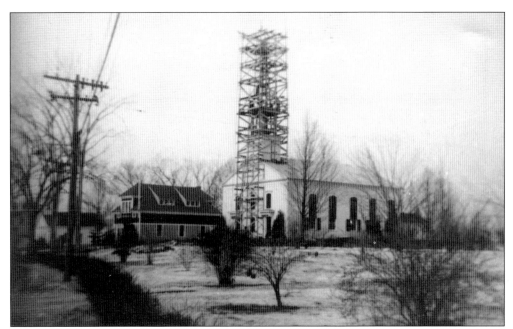

COLUMBIA CONGREGATIONAL CHURCH. This third meetinghouse, on Columbia's green, was built in Greek Revival style in 1832 by the Webler and Newell Company of Wells Woods. In 1868, and again in 1938, the steeple was toppled. During the hurricane of 1938, the steeple fell point down, bell intact. Seen here is the 1940 reconstruction of the steeple. Of note is the original Yeomans Hall, which burned down in November of that year. (CHS.)

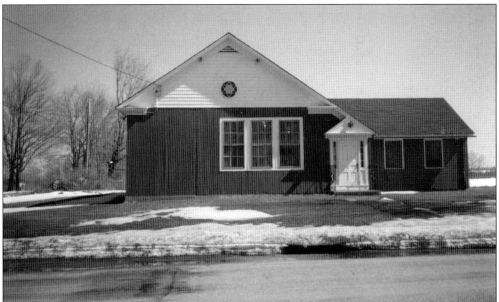

CONGREGATION AGUDATH ACHIM. The Agudath Achim Society (translated from Hebrew, "Society of Brothers, Hand in Hand") was founded by 10 families in 1921. The first temple, located on Chestnut Hill at Latham Hill Road and Route 87, was consecrated in 1927 and rebuilt in 1951, as seen here. The new synagogue was dedicated in 1952 by Chairman Joseph Tashlik. It continues to be used on High Holy Days and special occasions. (ASBLFL.)

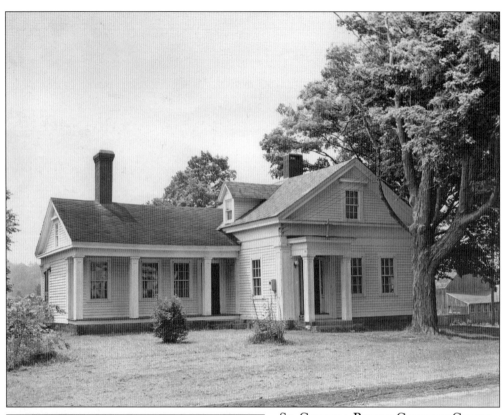

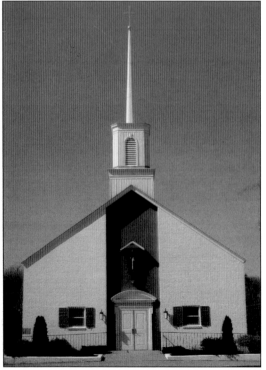

ST. COLUMBA ROMAN CATHOLIC CHAPEL, c. 1944. This Greek Revival house, located across from the Landmark, was dedicated in July 1944 as St. Columba Chapel, serving the Roman Catholic community of Columbia and Andover. It operated under the sponsorship of Saint Joseph's Parish of Willimantic. (CHS.)

ST. COLUMBA ROMAN CATHOLIC CHURCH. Dedicated on May 23, 1955, the new church served Columbia's 126 Catholic families and 85 vacationing lake residents as well as the Roman Catholic community of Andover and Hebron. A sixth-century carved stone from the ancient Abbey of Iona, the famous monastic center founded by Columba in 563, was a gift of the Episcopal Church of Hartford. This church is a parish of the Catholic Diocese of Norwich. (Courtesy I. Wood.)

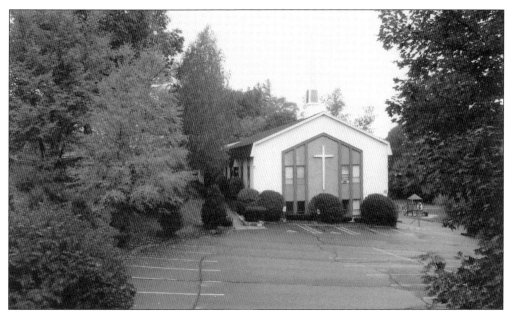

BAPTIST FELLOWSHIP CHURCH. Dedicated in 1971 under the leadership of Pastor Jack Schneider, the Baptist Fellowship is a regional church serving the nearby towns of Bolton, Coventry, Andover, Hebron, and Mansfield. The church offers fellowship study and prayer, outreach, youth camps, a food pantry, fitness training, and nursing home visits. The site was donated by Lester and Grace Cooper in 1970. (Courtesy Baptist Fellowship Church.)

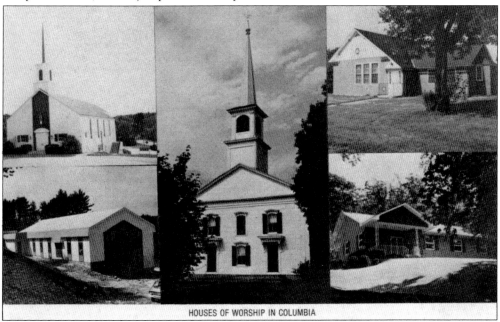

HOUSES OF WORSHIP IN COLUMBIA

COLUMBIA'S HOUSES OF WORSHIP, C. 1975. This composite postcard is meant to convey the major religious denominations in Columbia. Shown are, clockwise from lower left, the Baptist Fellowship Church, St. Columba Roman Catholic Church, Columbia Congregational United Church of Christ, Congregation Agudath Achim Synagogue, and Jehovah's Witnesses Kingdom Hall. (CHS.)

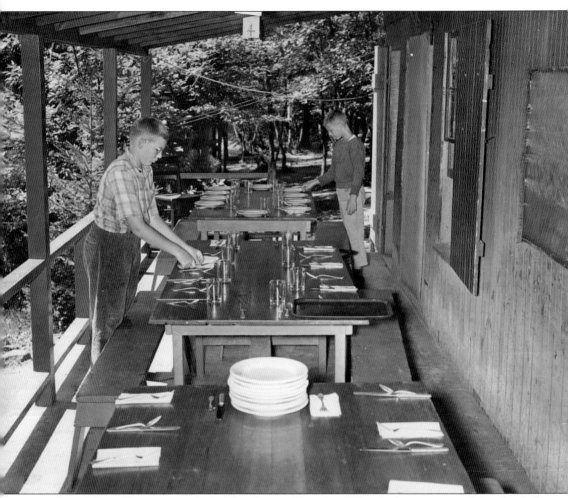

CAMP ASTO WAMAH, C. 1930. The Center Church of Hartford ministry at Columbia Lake reservoir started in 1909. The camp was officially founded as a youth camp and retreat for the First Church of Christ of Hartford in 1910, and the property was purchased in 1914. An adjoining parcel was purchased by the trustees of Hartford's Warburton Chapel. Shown here is preparation for 5:30 p.m. supper at the lodge. The activities included morning prayers and fellowship, swimming, sailing, archery, baseball, outdoor crafts, chores, camp duties, and evening vespers. Campers rose to reveille at 6:30 a.m. and went to sleep after taps at 9:00 p.m. The camp's motto is "Remember the Other Fellow." Generations of families have attended Connecticut's oldest youth camp. (Courtesy N. Mclean.)

Five

SUMMER PLEASURES AND ACTIVITIES AT THE LAKE

One of the major recreational attractions in the town of Columbia is the lake. It is hard to imagine that, prior to 1865, it was a large, swampy wetland. The impetus for the lake came about as a result of the Civil War. Union troops needed clothes, and the American Thread Company of Willimantic, manufacturer of cotton thread, became essential to the war effort. The power source used to run the mill came from the Willimantic River. This source was unreliable, particularly in the summer during periods of drought. The search for additional water to supplement the Willimantic River led to Columbia's wetlands area. The land was acquired and a dam was built to form a reservoir. However, it too was found to be inadequate, as the drainage into the Willimantic River only lasted a short time until the reservoir drained out. This problem, and the advent of electricity, soon rendered the reservoir obsolete. In 1933, the reservoir, now called a lake by locals, was sold to the town for $25,000. The lake soon became a great place to swim, boat, and fish. Visitors and renters came from Hartford and Willimantic on the train, which stopped at the Hop River Station. From there, the travelers walked to the lake. As the years passed, the lake became a summer resort destination. Among the prominent and famous people who built homes on its shores were artist Edith Sawyer; Democratic political and social entertainer Fannie Dixon Welch; Phillip Lauter, owner of the Electro-Motive Company of Willimantic, and his wife, Josephine, a vaudeville entertainer and singer; and June Norcross, founder of Norcross Greeting Cards. Today, the lake is as busy as ever. Swimming lessons for the youth, a gathering spot for teens, fishing and boating, or just soaking in the sun on a towel or chair are a few of the offerings of this eastern Connecticut gem.

AMERICAN THREAD COMPANY. The American Thread Company was indirectly responsible for the formation of Columbia Lake. The firm was established in Willimantic by Lawson C. Ives and Austin Dunham in 1854 to process flax into linen towels. Foreseeing the Civil War, the company switched to producing cotton thread. Six-ply thread was produced at the factory, which had a daily output of 4,000 pounds, or 50,000 spools per week. (Courtesy John Allen.)

WILLIMANTIC RIVER. This river, a tributary of the Shetucket River, is approximately 25 miles long. Before flowing south to the city of Willimantic, the Hop River and Ten Mile River in Columbia flow into it. The Willimantic River drops over 90 feet in one mile and provided an excellent head of pressure to power the mills in Willimantic. (Courtesy John Allen.)

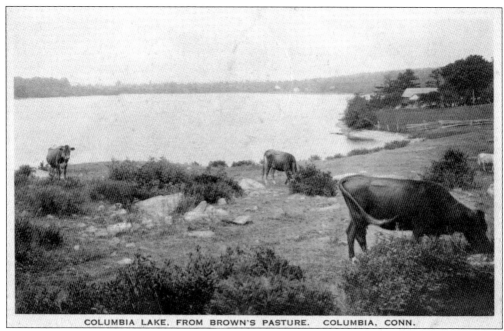

COLUMBIA LAKE, FROM BROWN'S PASTURE. COLUMBIA, CONN.

THE RESERVOIR. During summers, the Willimantic River was an unreliable power source for the mills, which sat idle when the river was low. Supplemental water sources were sought. The pond, wetland, and low-lying, spring-fed areas in Columbia were selected for a reservoir. This photograph shows Brown's pasture, near the present location of the beach. (ASBLFL.)

COLUMBIA DAM SITE. The American Thread Company of Willimantic bought approximately 375 acres from willing and unwilling landowners and dammed the low-lying area to form a reservoir. A few brooks, springs, and rainwater fed the reservoir. The dam was built near the outlet of the lake, now called the Ravine. (ASBLFL.)

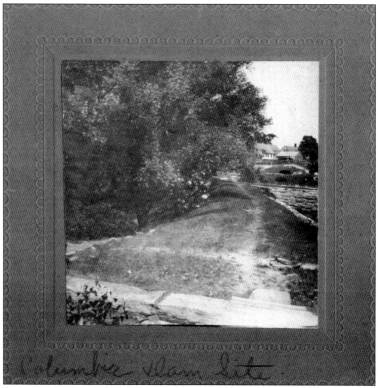

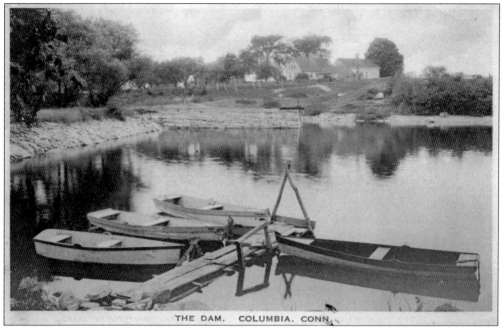

THE DAM. COLUMBIA, CONN.

EARLY DAM VIEW. This photograph was taken in 1921 from the edge of the lake. The dam, of earthen construction, is 300 feet long and 16 feet wide at the top. Built in 1865 by 25 laborers and five teams of horses, it has withstood the onslaught of every hurricane and severe storm that has torn through Columbia over the past 148 years. (ASBLFL.)

Entrance to Lake. COLUMBIA, Conn.

TOWN BUYS THE RESERVOIR. After construction of the dam, it was found that water diverted into the Hop River via the reservoir to feed the Willimantic River was insufficient. When electricity came into use shortly thereafter, the American Thread Company had no more use for the reservoir, which was sold to the town for $25,000 in 1933. This early photograph shows a road entrance to the lake. (ASBLFL.)

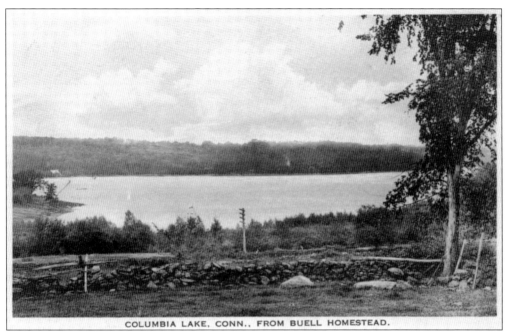

COLUMBIA LAKE, CONN., FROM BUELL HOMESTEAD.

COLUMBIA LAKE NEAR UTLEY HILL. This photograph shows a view of Columbia Lake from the Buell homestead. This area was one of the first to get electric power. Note the electric power post along the dirt road. The road was then called West Street, and the cemetery was named after it. (ASBLFL.)

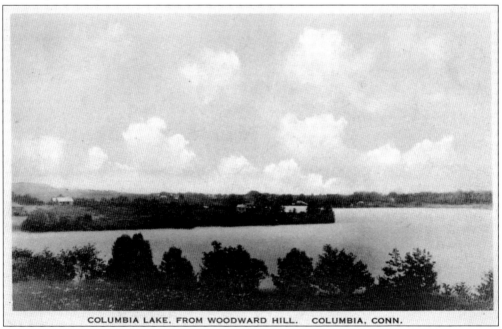

COLUMBIA LAKE, FROM WOODWARD HILL. COLUMBIA, CONN.

COLUMBIA LAKE FROM WOODWARD HILL. This postcard shows the lake from Woodward Hill, located north of the dam off Route 87. This area was noted for an early tavern with two large beehive ovens. The Woodward family owned much of this property. William H. Woodward was the secretary of Dartmouth College in 1815. (ASBLFL.)

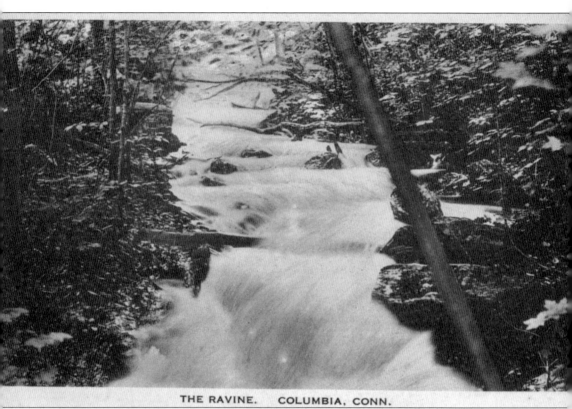

THE RAVINE. COLUMBIA, CONN.

THE RAVINE. This photograph shows the outlet of the lake, called the Ravine, running at full capacity. When the water level of the lake gets too high, a gate is opened to maintain the lake at a safe level. The water flows into the Hop River. The primary source feeding the lake is the Columbia Lake Brook, which flows into the lake near the junction of Lake and Erdoni Roads. (ASBLFL.)

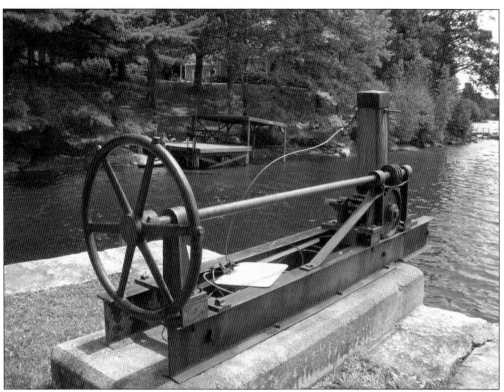

DAM GATE. The water level of the lake was controlled by opening and closing this old gate valve, which is no longer used. In the late fall, the gate was opened to drop the water level and keep the lake clean. In the spring and summer, the level was kept high so that town residents could enjoy swimming, fishing, and boating. (Courtesy John Allen.)

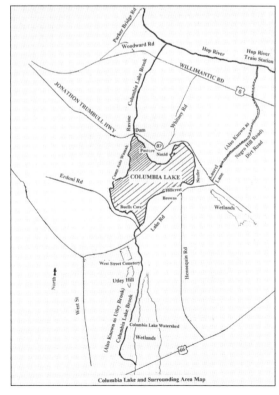

LAUREL LANE. After the turn of the 20th century, several businessmen bought or rented property around the lake, as their families sought refuge from the hot summers in the cities. Trains from Hartford and Willimantic stopped at the Hop River Station (see page 41). Visitors walked to the lake along a road now called Laurel Lane, shown on the map. (Courtesy John Allen.)

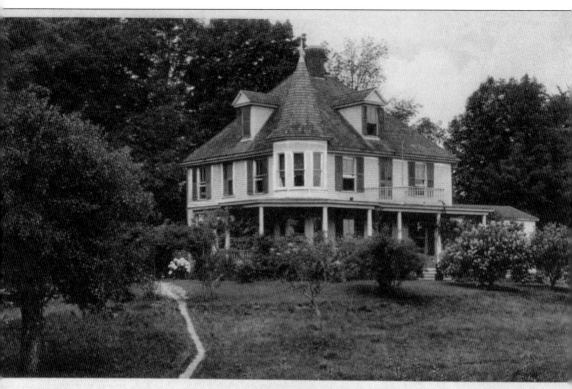

A. W. NORDLAND'S RESIDENCE. COLUMBIA, CONN.

HILLCREST. August Nordland was one of the first residents to predict the success of Columbia Lake as a resort area. He ran a summer boardinghouse called the Hillcrest, which rented out rooms and served meals. The Hillcrest eventually became the Loughrey home, and it was subsequently bought by William and Pat Murphy, who started the Columbia Canoe Club. The town now owns the building. (ASBLFL.)

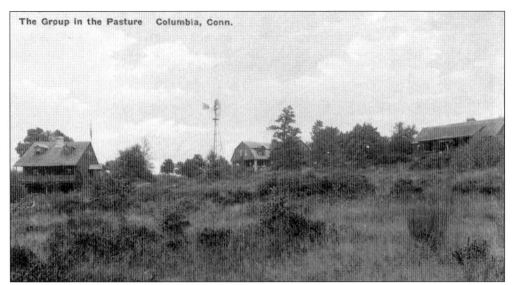

The Group in the Pasture Columbia, Conn.

NELLIE EDITH SAWYER. A visitor to Columbia in her childhood, Nellie Edith Sawyer, who was born in 1856, became an artist who specialized in miniatures. She opened a gallery in New York City. She and her sister purchased lakefront property from William Lyman in 1905 for $100. The compound of five cottages she built was known as the Pasture, and her home was named Afterthought. (ASBLFL.)

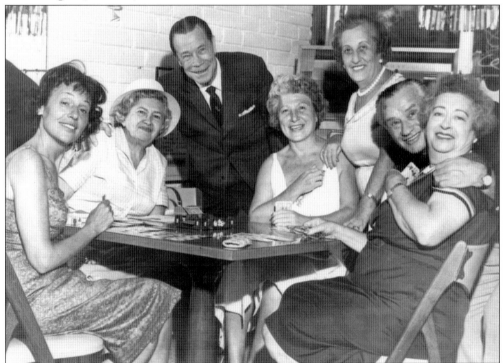

JOSEPHINE LAUTER GREER. Born in 1891, Greer was one of the most colorful and captivating personalities on Columbia Lake. She threw many parties at her home. Shown in this photograph are several of her friends. The famous actor Joe E. Brown is third from the left, and Greer is at far right. (ASBLFL.)

RED HOT MAMA. Although married, Josephine Greer traveled the vaudeville circuit and performed on stage from 1920 to 1937. She was accompanied on the piano by Georgia Sands. She often sang with Sophie Tucker and was her understudy in the Broadway production of *Last of the Red Hot Mamas*. She also played opposite Errol Flynn in a Broadway show called *Fiorta*. (ASBLFL.)

PHILLIP AND JOSEPHINE LAUTER. Phillip Lauter owned the Electro-Motive Company, the largest producer of mica capacitors in the world. When he died in 1945, Josephine became president. In 1972, the company was sold, and shortly thereafter, in 1975, it went bankrupt. (ASBLFL.)

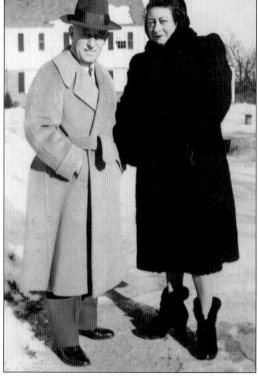

JESSE GREER. Josephine remarried in 1948, to Jesse Greer, who was in the entertainment business. Greer wrote over 200 songs during his career. Some of his hit songs were "Just You Just Me," "Kitty from Kansas," "Marianne," and "Blessed Event." He played the piano, and often accompanied Josephine in her singing engagements. (ASBLFL.)

NOXID, C. 1940. Fannie Dixon Welch was another popular and notable person who lived on the lake. She built a beautiful home called Noxid ("Dixon" spelled backwards) on the lake and held social and political parties there. Many politicians, dignitaries, and important people from the Connecticut Democratic Party met there. Franklin and Eleanor Roosevelt visited her home several times, and FDR held at least one fireside chat there. Welch died in 1947. (CHS.)

JUNE NORCROSS. Another interesting resident of Columbia Lake was June Norcross. An illustrator, she started her own business designing and selling greeting and holiday cards. Her business thrived. One of her beautiful Christmas cards is shown here. (CHS.)

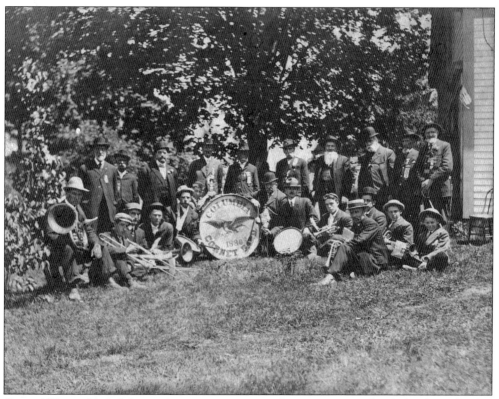

CORNET BAND. Early lake residents were entertained on summer weekends by the Columbia Cornet Band. Other bands entertained during the summer, including the Foster Band, which generally played at the Nuhfer property, on which was set up a large wooden bandstand stage. In the later 1920s, the Albert Lyman's school of music band performed. Some residents listened to the music from their boats, anchored near the concert area. (ASBLFL.)

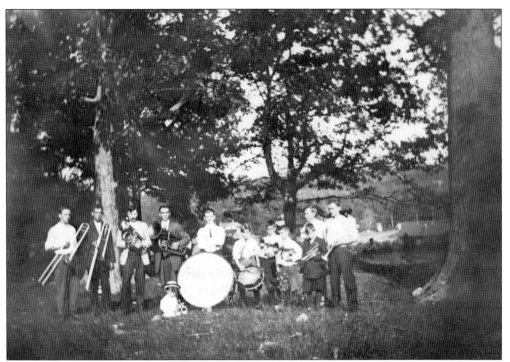

FOSTER BAND. The Foster Band entertained during the long summer weekends. Concerts were held on the Nuhfer property, which at the time was a public swimming area with bathhouses, boat rentals, and a snack bar. (ASBLFL.)

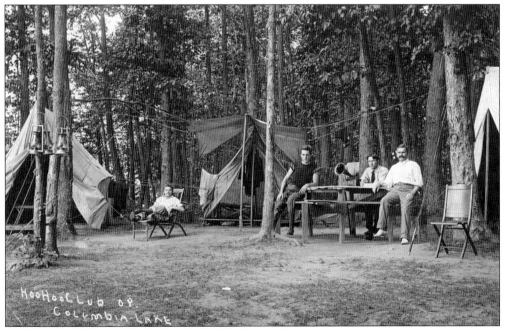

HOO HOO CLUB AT COLUMBIA RESERVOIR, C. 1909. Columbia was a desirable camping destination in the summer. One of the groups that camped there was the Hoo Hoo Club, a local lumber industry organization. Note the old wooden chairs. (CHS.)

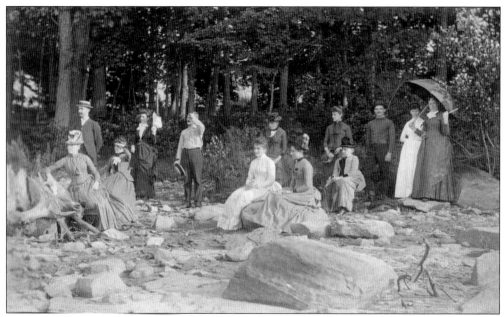

PICNIC AT CHESTNUT POINT, C. 1889. Ladies and men dressed in their finery are seen picnicking at the reservoir. Shown are, from left to right, Julia Avery, unidentified, Grace Sanger, unidentified, Edward Peel, Lucy Sawyer, unidentified, Addie Morgan, unidentified, Annie Hutchins, Lizzie Brown, George Sawyer, Rhoda Townsend, and Nellie Sawyer. (CHS.)

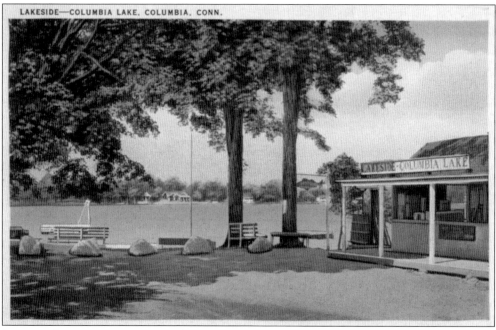

LAKESIDE BEACH, C. 1930. Refreshments were served at this lakeside store. Ice cream, soda, candy, and food were available to the summertime beach crowd. Note the public beach and diving platform. (ASBLFL.)

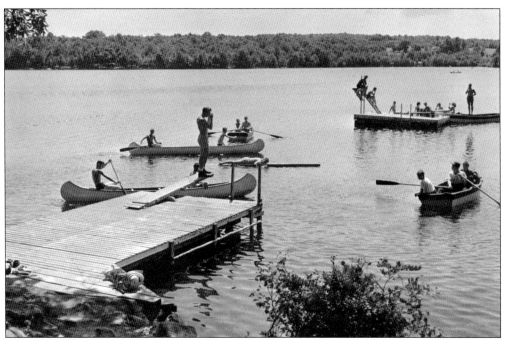

CAMP ASTO WAMAH, C. 1940. Many Columbia and out-of-town youngsters attended this summer camp. Here, boys are getting lessons on handling canoes and boats. Boaters on the lake can usually observe the youngsters in camp having a great time. (Courtesy N. Mclean.)

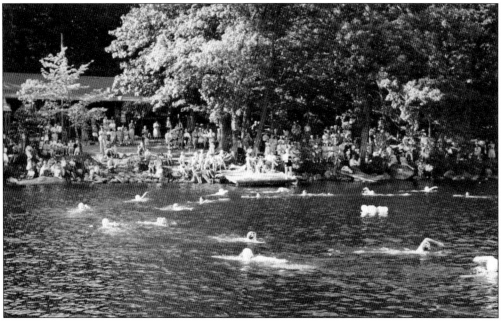

CAMP ASTO WAMAH SWIMMING PROGRAM. A large number of parents watch their children perform precision swimming programs in Columbia Lake. Swimming lessons were given in the morning, and the afternoons were devoted to "free swim periods." Campers were encouraged to help each other in order to develop a spirit of closeness and friendship. The camp's theme is "Remember the Other Fellow." (Courtesy N. Mclean.)

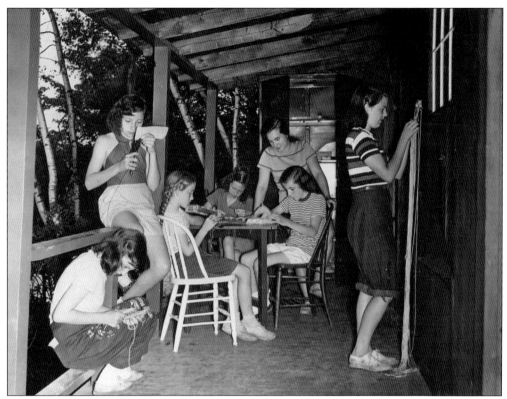

CAMP ASTO WAMAH CRAFTERS. These young ladies learn a variety of crafts at camp. They are all deeply engrossed in their projects and cannot wait to show their newly acquired skills to their parents. (Courtesy N. Mclean.)

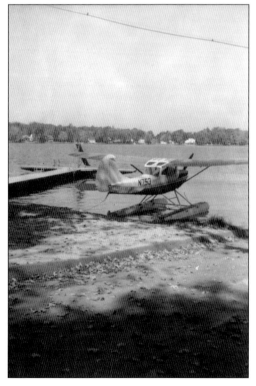

AMPHIBIOUS PLANE. In Columbia Lake's early years, this type of aircraft was allowed to land and take off on the water. In 1948, a seaplane crashed on the lake, and the passenger was killed. A Columbia resident, Guy Beck, was able to rescue the pilot. (ASBLFL.)

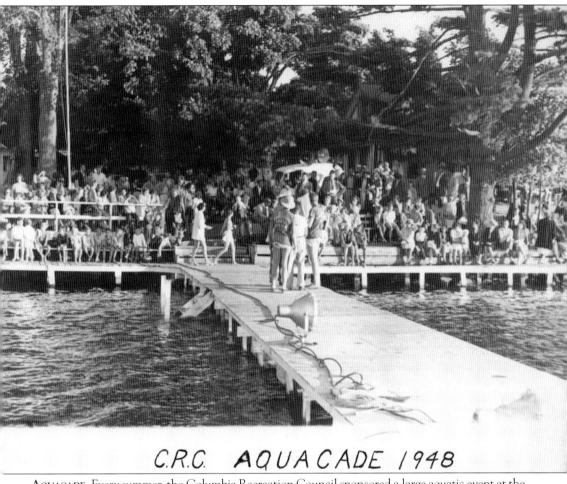

C.R.C. AQUACADE 1948

AQUACADE. Every summer, the Columbia Recreation Council sponsored a large aquatic event at the lake. The Aquacade consisted of young women performing synchronized swimming programs. Large crowds of parents and friends gathered for the event. Note the old wooden dock. (ASBLFL.)

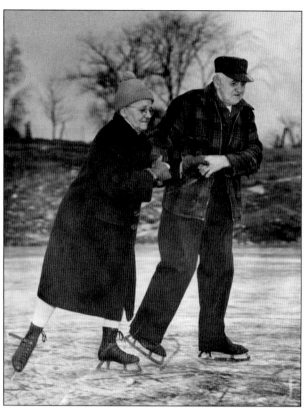

WINTER FUN, C. 1950. Junie Bell Squier and Raymond Squier skate on their ice pond near their home, now called the Landmark, located at the junction of Routes 87 and 66. (ASBLFL.)

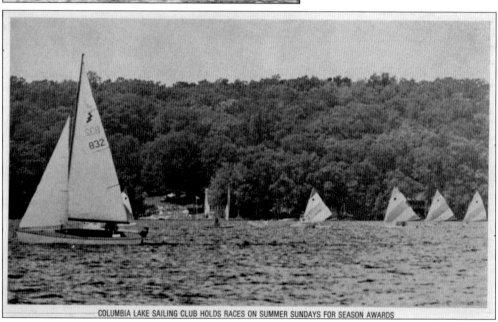

COLUMBIA LAKE SAILING CLUB HOLDS RACES ON SUMMER SUNDAYS FOR SEASON AWARDS

SAILING CLUB. Sailing on Columbia Lake was in full swing as early as the 1930s. A sailing club was established not long after the Lake Association was formed in 1935. Sunday races are still common throughout the summer. Shown here are a Lightning-class sailboat and, in the background, a fleet of Sunfish. (ASBLFL.)

Six

Making the
Rules and Regulations

The Town of Columbia was once the northern territory of Lebanon. William Clarke, Josiah Dewey, and Thomas Buckingham purchased this entire region from the Mohegan Indians; Abimeleck, and Oweneco, in 1699 and 1700. At this time, a church was organized and a minister selected. The church ran town politics, and only church members could vote. Soon after 1716, a second ecclesiastical society in the northern end of town called Lebanon Crank was established due to the remoteness of these parishioners from the main church. For almost 100 years, Lebanon Crank flourished under the new church leadership. In 1803, Lebanon Crank applied for incorporation of a new town to be called Columbia. It was granted in 1804. A selectman form of government was established, and that same year, Columbia's boundaries were established and voters elected town officials. They included five selectmen, tax collectors, a key keeper, a fencing inspector, and a chimney checker. In 1835, a Town House was built near the Old Yard Burying Ground. In addition to holding town meetings there, it was used for religious meetings, lectures, and concerts. In 1900, Mary Yeomans financed a new building, named in honor of her husband. It was for town administration use, including use by private organizations such as the Grange. Yeomans Hall burned down in 1940, and a new town hall was built. It is still in use.

There have been many changes in town politics and commercial enterprises since the beginning. The population has increased from 834, at the town's founding in 1804, to 5,370 in 2012. New businesses have been established along the Route 6 and Route 66 corridors, and large conservation and recreation areas have been set aside for use by town residents. Until 1960, Republicans dominated Columbia's elections; by 1970, Democrats were dominant. Today, the majority of voters are unaffiliated. Many changes have occurred over the years, but the town's character and beauty still remain. The rural, open atmosphere and the area's many historic buildings have been retained for the enjoyment of the residents of this peaceful community.

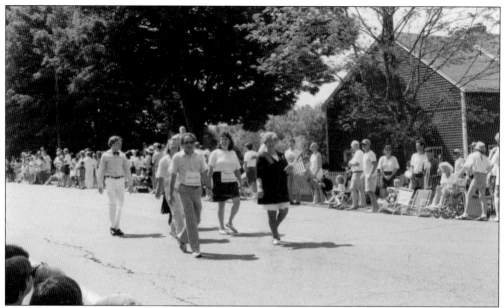

ADELLA URBAN. Columbia politics began in humble circumstances, with Freeman meetings in the Congregational Church. The first town hall was built in 1835, and subsequent meeting halls were constructed in 1900 and 1940. Highly popular, long-term town selectmen included Stephen Hosmer, Clair Robinson, Joseph Szegda, and Adella Urban. Here, Adella Urban (far right), a first selectman for 18 years, marches in Columbia's Fourth of July Parade. (ASBLFL.)

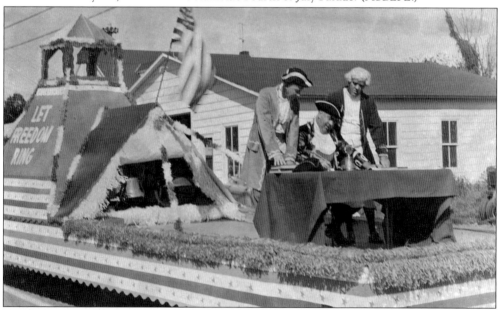

DECLARATION OF INDEPENDENCE FLOAT. Columbia residents have consistently maintained an interest in the nation's founding and political processes. This float, in a 1950s Fourth of July Parade, depicts the signing of the Declaration of Independence by Benjamin Franklin. The document, which proclaimed the colonies independent states, was adopted by the Continental Congress on July 4, 1776. The day has been celebrated with a parade in Columbia since the early 1900s. (ASBLFL.)

CONSTITUTION PIN OAK. A constitutional convention updated the Connecticut state constitution in Hartford in 1902. A pin oak was presented to each of the 168 state participants. This one, planted in front of the town hall, survived 95 years. Of the 74 that did survive, the average circumference was 9 feet, 10 inches, and the average height was 82 feet. (ASBLFL.)

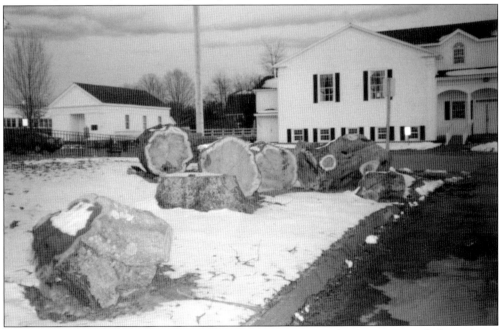

DEMISE OF THE CONSTITUTION OAK. In the early spring of 1997, the Constitution Oak was found to be diseased. It was eventually cut down. Note the extremely large diameter of the trunk. Several people obtained wood from the tree and made tables and other furniture from it. A prime example of a table made from this tree can be found at The Meeting Place. (ASBLFL.)

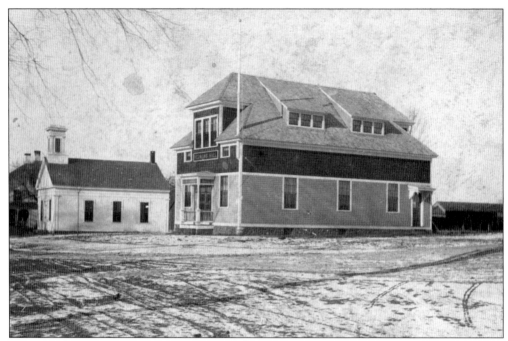

ORIGINAL YEOMANS HALL. Mary B. Yeomans had this structure built in 1900 for the "free use by the Town and any of the organizations in town, secret or otherwise." However, stipulations were made that no drinking or dancing would be allowed. (ASBLFL.)

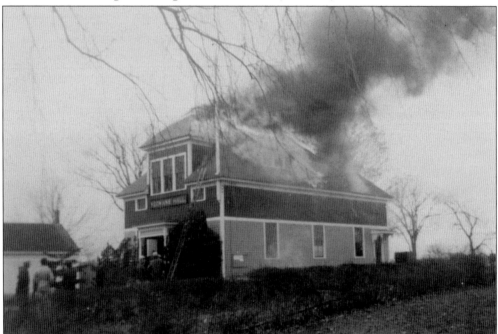

FIRE. Yeomans Hall was used as a meeting place for Columbia's town government for 40 years. In 1940, it was damaged in a spectacular fire, which swept from the basement to the upper hall and roof, where it was fanned by strong winds. The fire may have been caused by hot coals in an ash box in the basement or by faulty wiring. (ASBLFL.)

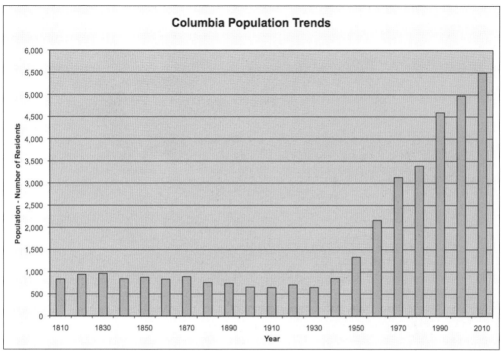

COLUMBIA'S POPULATION GROWTH. Significant population contraction occurred between 1830 and 1900 due to western migration and the attraction of urban centers with more job opportunities. Growth occurred after 1950 as servicemen returned home, new highways were built, and Columbia became part of the greater Hartford commuting area. Columbia's population trends are shown in this graph. (Courtesy John Allen.)

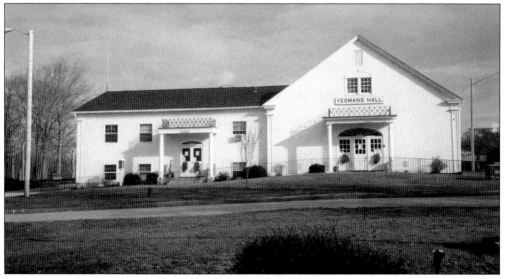

NEW TOWN HALL. After the fire, the old Yeomans Hall was torn down and replaced in 1941 by a one-and-a-half-story wooden building. Built at a cost of $22,000, the structure retained the name of the original benefactor, Mary B. Yeomans. In 1972, a $60,000 annex for administration offices was built, and in October 2011, it was dedicated to the memory of First Selectman Adella G. Urban. (ASBLFL.)

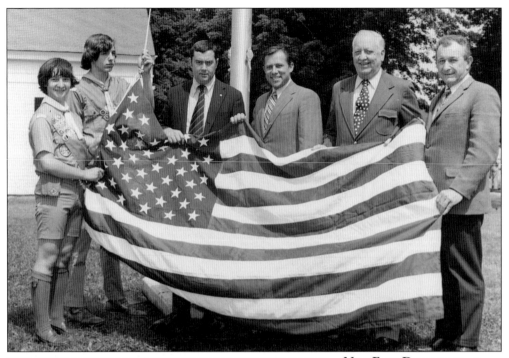

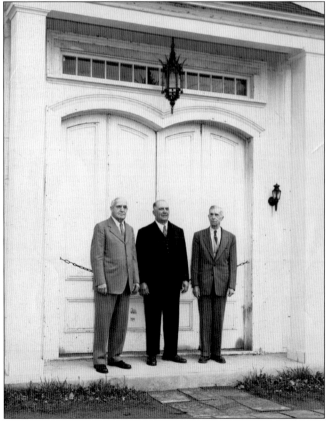

NEW FLAG DEDICATION, C. 1970. Two Boy Scouts and Columbia political leaders raise a new flag in front of Town Hall. Shown from left to right are two unidentified Boy Scouts, Robert Baldwin, Robert Steele, Howard Bates, and Joseph Szegda. (ASBLFL.)

COLUMBIA REPUBLICAN POLITICIANS, C. 1930. The three well-known Republican town officials shown here from left to right are town clerk Hubert Collins, First Selectman Clair Robinson, and Probate Judge Clayton Hunt. From the early years and into the 1960s, the town was generally Republican. Elections have favored Democrats from the 1960s to the present day. This coincides with the large increase in population during this time. (CHS.)

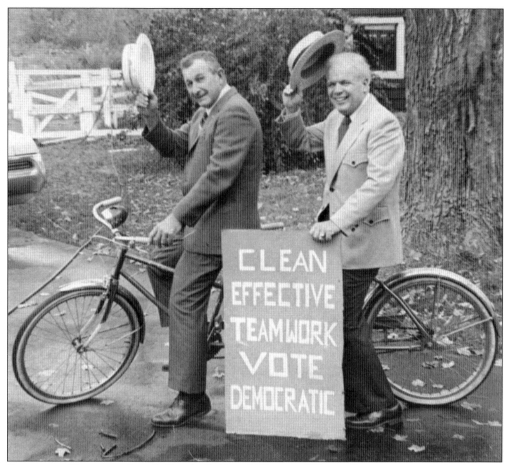

SELECTMAN ELECTION. Joseph Szegda (left) and Thomas O'Brien, Democratic town leaders, are seen tipping their hats on a bicycle made for two as they bid for a spot on the board of selectmen in the campaign of 1960. (ASBLFL.)

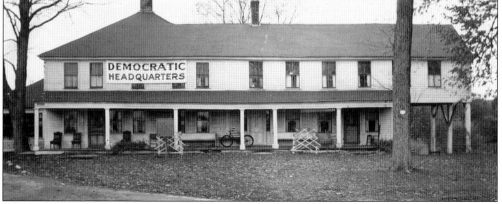

DEMOCRATIC HEADQUARTERS. The Landmark was the political headquarters for the Democrats in the 1960 elections. This building has had many uses through the years, including as an early tavern and stagecoach station, restaurant, drugstore, and commercial office building. In the wake of several strange occurrences, local citizens claimed that the building was haunted. (ASBLFL.)

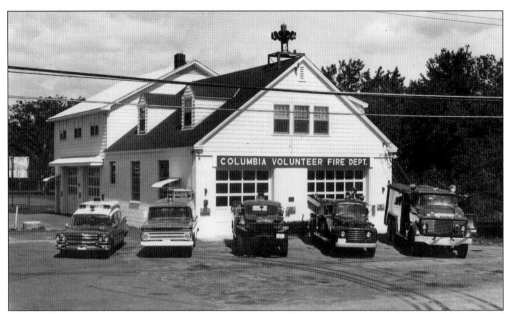

COLUMBIA VOLUNTEER FIRE DEPARTMENT. The idea of a fire department in Columbia was presented at a meeting in October 1946. A year later, the Columbia Volunteer Fire Department (CVFD) was organized and incorporated at a meeting in Yeomans Hall on April 23, 1947. The first firehouse was erected that year with volunteer labor and land donated by Horace Porter. (ASBLFL.)

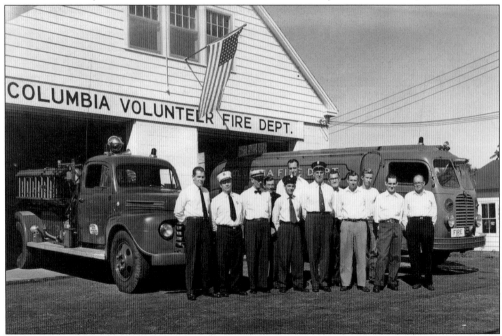

COLUMBIA VOLUNTEER FIREFIGHTERS. Early members of the CVFD pose in front of department vehicles. Shown are, from left to right, (first row) Walter Card, Richard Davis Sr., Ward Rosebrooks, Richard Davis Jr., Francis Lyman, Jack Card, Guy Beck, and Raymond Lyman; (second row) Harold Evans, Herbert Englert Jr., Herbert Englert Sr., and Boyd Tuttle, who identified these early members. There are currently over 100 members on the roster. (ASBLFL.)

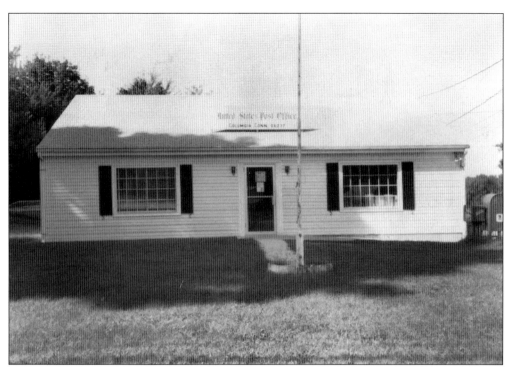

EARLY POST OFFICE. Early post offices were often set up in private homes. Later, they were installed in stores, where the public more frequently visited. Finally, dedicated post offices were established, with mail delivery as the primary function. Lester Cooper built this post office in 1959 and leased it to the federal government. (ASBLFL.)

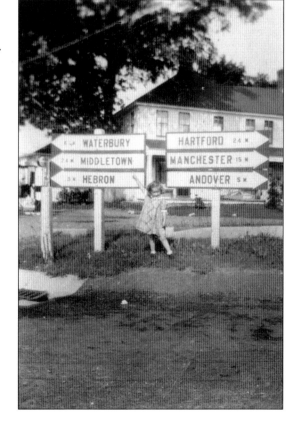

TOWN SIGNS. This little girl points to destinations near and far from the Columbia town center. This area is known to many as the crossroads of eastern Connecticut. The building in the background is the Landmark. Route 87 was not paved until the late 1920s. (Courtesy Squier Collection, ASBLFL.)

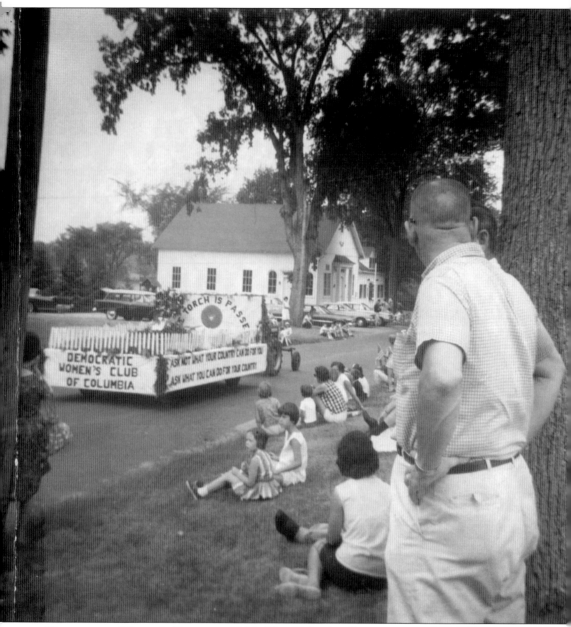

DEMOCRATIC WOMEN'S FLOAT, c. 1964. The Columbia Democratic and Republican parties had floats in the popular Fourth of July Parade. Many state and local officials also participated, marching or riding in convertibles and waving to and greeting constituents. The banner of the float shown here carries the famous Kennedy quote "Ask not what your country can do for you. Ask what you can do for your country." Parents and children alike sit at the side of Route 87 to watch the parade. The children are hopeful that candy may be thrown their way by some of the participants. Politicians still participate in this traditional parade. (ASBLFL.)

Seven

THE MEN AND WOMEN WHO WON AND KEPT OUR FREEDOM

Throughout the history of this great country, Columbia men and women have proudly served in the military. In frontier settlements, all able-bodied men were required to train for military action. Protection of family, homes, food, and livestock from hostile Indians required an alert response from all residents. When the Revolutionary War began, Lebanon Crank's contributions in men and material for the war effort were invaluable. Over two dozen local men fought in the Revolutionary War, and 21 are buried here. The Crank was a stop on the road to victory when Rochambeau's troops marched through town on their way to Yorktown. French regiments included the Bourbonnais, Soissonais, Royal Deux-Ponts, and Saintonge, and troops from 17 other countries signed on to fight for American ideals. It was an awe-inspiring sight: young soldiers, many of whom were French noblemen, wearing brilliant white coats and tight-fitting pants, their bright tricorn hats shading weary faces, and the bayonets of their muskets casting reflections from the sun's glistening rays. The young and the old brought food to the men, and a lass's kiss expressed the town's thanks. The sounds of the march were like music to residents' ears. This was a parade headed to war.

Columbia's list of war veterans include 17 from the Civil War, 18 from World War I, 121 from World War II, and approximately 30 each from the Korean conflict and the Vietnam War. Many Columbia men and women volunteered in other capacities to help during World War II. Duties included observation of aircraft, selling war bonds, collecting newspapers and scrap metals, selective service duties, and rationing boards. Two women's groups, the British War Relief Group and the Columbia Older Girls Society (COGS), were especially helpful to the war efforts. It is with great pride that we pay homage in this chapter to all of those Columbia men and women who served our country with honor, courage, and dignity.

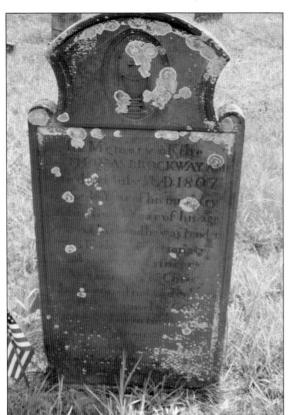

REV. THOMAS BROCKWAY GRAVESTONE. Prior to the war, Reverend Brockway (page 7) was espousing the colonial revolutionary cause and decrying British rule in his sermons to his parishioners. An adamant patriot, he served as a chaplain in Col. Samuel Selden's regiment in the Connecticut militia in 1776. His gravestone can be found in the Old Yard Burying Ground. (Courtesy John Allen.)

REVOLUTIONARY WAR FRENCH BAYONET. During the Revolutionary War, French troops were bivouacked on the town green in Lebanon and Columbia. Many made frequent stops at the Lebanon Crank Inn to buy supplies and imbibe a few drinks. Marshall Squier, who owned the inn in the 1950s, found a musket hidden in an attic wall. This French 1760s Charleville rifle bayonet was found in Columbia by John Allen. (Courtesy John Allen.)

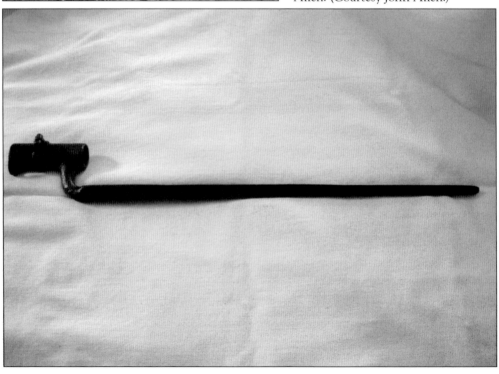

BRITISH WAR RELIEF GROUP.
A group of 20 women from Columbia knitted, sewed, and made clothing and garments for English victims of German bombing raids before the United States entered World War II. Items included 500 wool quilts and afghans, 600 wool garments, and many soft toys for children. Shown is a page of the group's final report, with a note from the British embassy. (ASBLFL.)

REPORT OF THE BRITISH WAR RELIEF GROUP

Miss Edith Sawyer, Miss Katherine Ink and Miss Anne Dix. One summer resident, Miss Katherine Christhilf, gave her time for the five summers. Last, but not least, is Mrs. Marshall Squier, who saw to it that we had hot coffee every Thursday noon for five years.

Although only two of the group were British born, nevertheless all the members felt a special bond of kinship and sympathy with the English people in their time of trouble and were glad to be able to express that feeling for them through this work.

This "kinship" is proved by the following letter.

British Embassy

Washington, 8, D. C.

His Majesty's Ambassador presents his compliments to Miss Anne Dix and has the honour to inform her that The King has been pleased to award her His Majesty's Medal for Service in the Cause of Freedom.

Lord Inverchapel would like to offer his personal congratulations on this well merited award.

July 9th, 1946.

TO

Mrs. Cora Hutchins

As the activities of THE BRITISH WAR RELIEF SOCIETY OF AMERICA draw to a close, we wish to add to the sentiments of gratitude for American generosity from the people of Great Britain already voiced by Prime Minister Churchill and British Ambassador the Earl of Halifax, our expression of heartfelt appreciation for your continued and splendid cooperation.

You have demonstrated in a most practical manner that you share the sentiment recently expressed publicly in London by General Eisenhower:

"One of the passions of my life is to promote real and practical cooperation among your people and ours."

PRESIDENT

COMMITTEE CHAIRMAN

LETTER OF APPRECIATION. The British War Relief Group received His Majesty's Medal for Service in the Cause of Freedom from the King's ambassador. The letter was addressed to Cora Hutchins, leader of the Columbia group. The items made and sent by the organization raised the spirits of the British people and signaled that American help was close at hand. (ASBLFL.)

Edited by the COGS December

This is your Christmas edition of the Cogwheel and here's hoping most of you will receive it before December 25. This year more than ever before, Christmas will have a special meaning for us. We will learn to value more highly the little things that make our American way of living so dear to us. Christmas is one of the American institutions we are fighting to maintain. Although most of you will not be here this year, everyone back home will be thinking of you and missing every one of you. Let us pray that by another year, peace and good will will be well on the way.

It seems Luke Robinson was convalescing from his broken ankle when they brought a fellow with a broken toe in and put him in the next bed. Well, of course the two got to talking and it developed that the new boy had an aunt who lives in Columbia. Yes, he is none other than Bob Failor, nephew of Miss Dix, a well known local resident. We are glad you have company, Luke, and here's hoping you will soon be back to normal.

George Bedford, uncle of Sgt. George Peters, had just returned from a visit with his nephew in Laredo, Texas. They had a wonderful time visiting with each other and spent Thanksgiving together.

We received your card in good order, Sgt. Bernard Meyerson. We understand you are doing a swell job as an instructor in aerial gunnery-- keep up the good work!

We hear that Eleanor Jackson way down in Australia has her room filled with orchids every day. That's the Soldiers' way of showing their appreciation. You're doing a important job Eleanor, and here's wishing you all the best of luck.

We received your letter of October 25, Cpl. Bob Church and were glad to hear you enjoyed your furlough. You bet we can give you Spencer Macht's address. Its P.F.C. Spencer Macht 31122968, Hq. Co. 10, P of E, A.P.O. 758, c/o Postmaster, New York, N.Y.

COGS would like to take this opportunity to express their gratitude and appreciation to Mr. Rowland for the use of his mimeograph and his help in printing this paper each month. Without his assistance, the Cogwheel would not be possible.

We received your letter P.F.C. Louis Axelrod. No, the crows aren't fooling us any longer, as the Observation post is being operated only on the second Wednesday of each month now!

Thanks for sending us your P.O. address, Charlie Perkins! It really is a big help. Now you will undoubtedly receive your Cogwheel instead of its being returned to us. Also the best of luck to you.

Christmas will be observed in Columbia this year in the traditional manner. There will be Christmas music and a Christmas sermon in Church, December 19. The Sunday School program including Santa Claus as usual, will be that afternoon. A special evening service will be held December 26 in the Church including appropriate music and a narative by Mrs. Madeline Mitchell of Columbia. The Girl Scouts are planning to sing carols from house to house on Christmas Eve.

That letter of yours was definitely worth waiting for, P.F.C. Len Gorman. We enjoyed your account of your adventures in England and we also were glad to hear such a nice long letter. Wish we could see some of those castles and mansions you described, but since letters are as close as we can get to those things, thanks a lot for writing.

In some ways, it hardly seems possible that another December 7 has come and gone marking the second anniversary of our entry into this mighty conflict. We have worked very hard for what we have accomplished, and we will put even more effort into the months to come. Victory must be ahead of us, and let us hope it will be soon.

(Over)

COGS. Six Columbia women started an organization called the Columbia Older Girls Society (COGS) at the beginning of World War II. They published a newsletter, the COGWHEEL, a sample of which is shown here. The publication, sent to all Columbia servicemen and servicewomen, provided local news, veteran updates, and war news. (ASBLFL.)

SERVICEMAN'S LETTER. World War II servicemen and servicewomen were thrilled to receive the COGWHEEL. Soldiers' letters describing their well-being and experiences abroad supplied the COGS ladies with material for the newsletter. Every letter written to the society expressed the soldiers' appreciation for receiving this publication, which gave them a taste of home and of their life in Columbia. They were anxious to get news about friends, promotions, duties, and locations. (ASBLFL.)

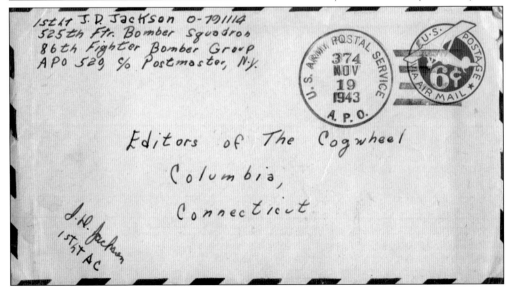

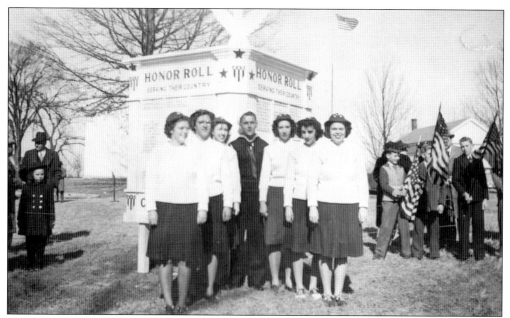

COGS Honor Roll Dedication. On March 26, 1944, the COGS dedicated an honor roll of all veterans of World War II to the Town of Columbia. Dances were held to support the project. The COGS ladies posing with veteran sailor Gus Naumec (center) are, from left to right, Jane Lyman McKeon, Olive Tuttle Shea, Jean Isham Peters, Kaye Sharpe Anderson, Shirley Trythall Kurcinik, and Carol Lyman Ladd. (ASBLFL.)

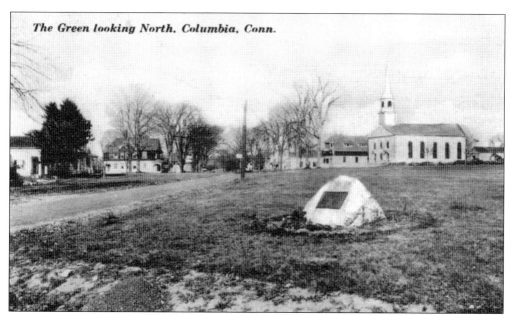

World War I Memorial. The bronze plaque attached to the boulder was dedicated by the town to all servicemen who served in World War I. It is located on the town green. Of the 18 men who served, two were killed: Cyrus Hilton and Stanley Hunt. (ASBLFL.)

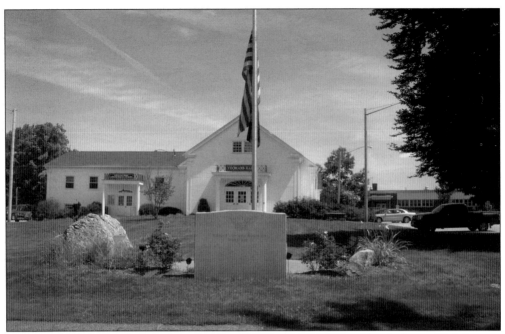

MEMORIAL AND FLAGPOLE. This memorial on the town green, donated by the Lions Club, honors all veterans of World War II. The flag and memorial are lighted at night, a tribute to all of those from Columbia who served the country. (ASBLFL.)

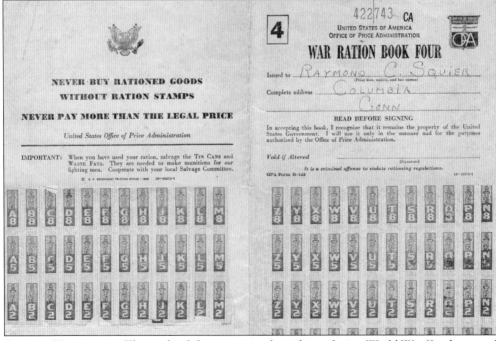

CIVILIAN VOLUNTEERS. Those who did not serve in the military during World War II volunteered for a wide variety of tasks in the war effort. Volunteers served on the selective service and rationing boards, acted as air raid wardens, sold war bonds, collected scrap metal and paper, and made surgical dressings. Shown here is a typical war ration stamp book. (ASBLFL.)

SCRAP METAL DRIVE, C. 1942. Wilberforce T. Little contributes his share of scrap metal to the war effort. Any type of metal was acceptable, even old horseshoes. The scrap iron was converted into machinery employed to win the war. (ASBLFL.)

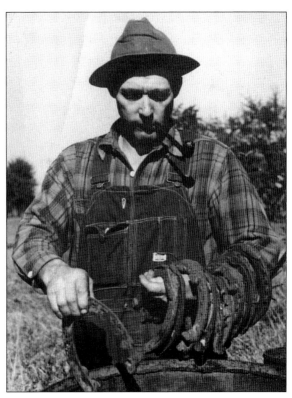

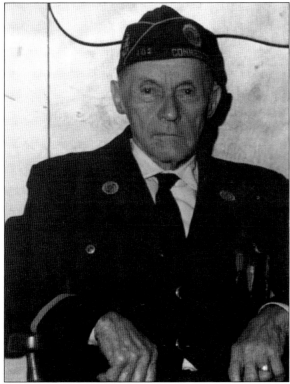

NAVAL GUNNER. Wilberforce T. Little, age 92, wears his World War I dress uniform. He served as a gunner in the Navy from 1917 to 1921. He was also in the Naval Reserve for four years. (ASBLFL.)

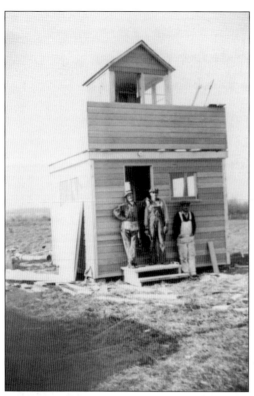

OBSERVATION TOWER, C. 1942. This small building on Route 66, known as Freeman No. 52, was used as a lookout for enemy aircraft during World War II. The site is on Post Hill, which, at an elevation of 775 feet above sea level, is one of the highest points in eastern Connecticut. Shown at the door to the observation tower are Fred Lambert (left), Adolph German (center), and Don Woodward. (Courtesy Belle Robinson.)

RESTORED TOWER. The Aircraft Tower on Post Hill (also known as Skyline Farm) in Columbia was moved to the town of Hebron, where it was restored. The Hebron Historic Commission led the restoration project. The tower, one of 14,000 that were manned 24 hours a day, every day during 1942, is thought to be the only one still in existence. It is now located on Hebron's town hall green. (Courtesy John Allen.)

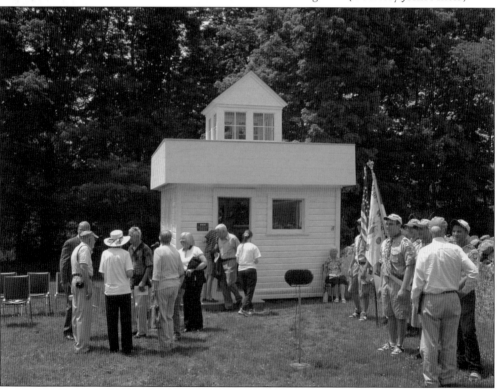

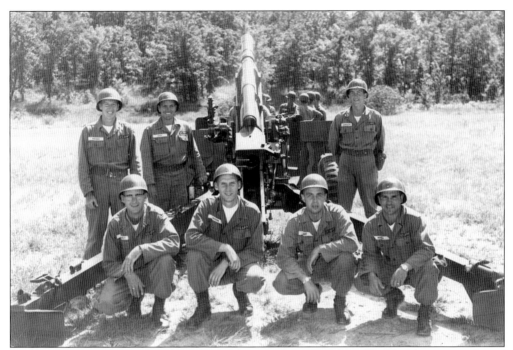

CORP. CHARLES GRANT. Corporal Grant served in the Army in 1958 and 1959 as a member of A Battery, 2nd Howitzer Battalion, 8th Artillery. Grant (first row, second from right) poses with his artillery school unit. He served in Korea one half-mile from the demilitarized zone. (Courtesy Charles Grant.)

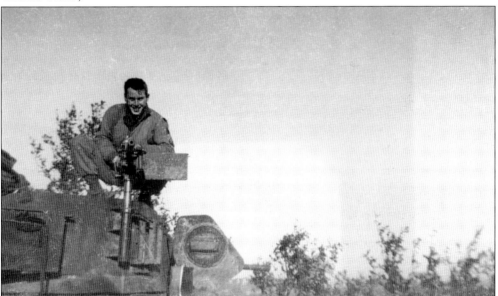

T.SGT. EDWARD WENDUS. Technical Sergeant Wendus served in the Army from early 1943 to December 1945 in the 2nd Armored Division, 66th Regiment, Company A. He was a tank driver and gunner, and is shown here on his M24 tank. He landed on Omaha Beach on D-Day + 2, and was awarded five major battle stars, a presidential citation, and a Bronze Star. (Courtesy Edward Wendus.)

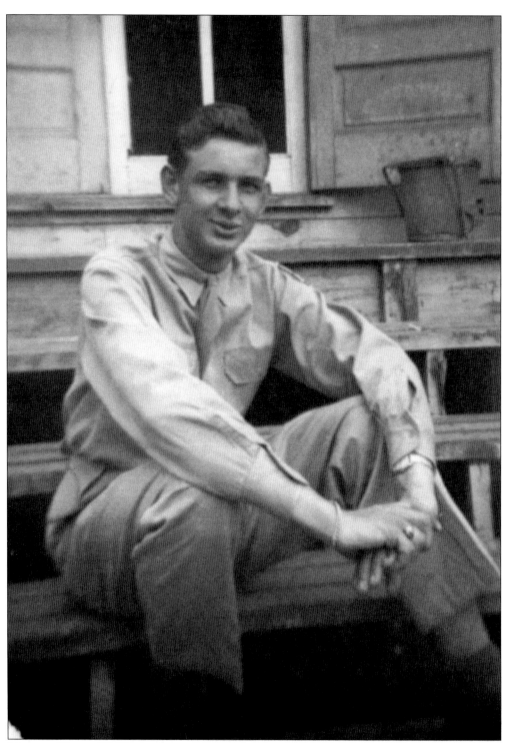

MERTON WOLFF. Wolff served as a surgical technician in the Army Medical Corps, 71st Area Service Unit, from August 1945 to November 1946. He is shown relaxing on the side steps of the barracks of the regional station hospital in Fort Belvoir, Virginia. (Courtesy Merton Wolff.)

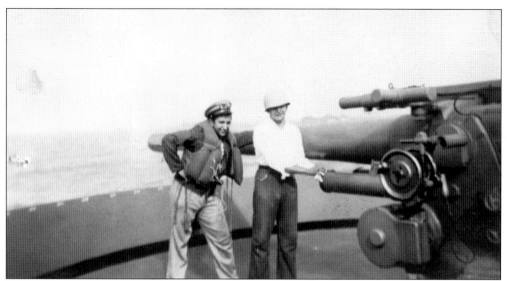

RUSSELL INZINGA. Joining the Merchant Marines in October 1943, Inzinga served aboard the ship *Edward B. Alexander* as a steward during the entire war. On his first trip to Scotland, German aircraft attacked the ship, which was carrying 12,000 troops. One boat in the convoy was sunk. Inzinga (left) is shown on board the ship with his friend Michael Reikite. (Courtesy Russell Inzinga.)

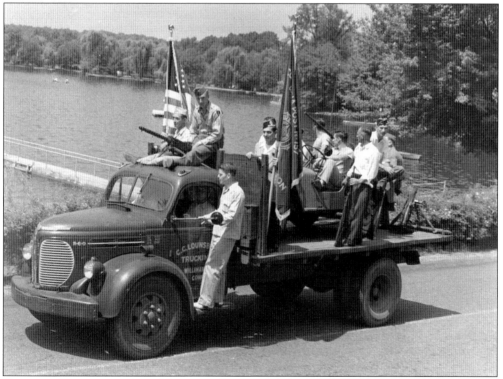

COLUMBIA PARADE, C. 1960S. Veterans riding on a REO truck display a machine gun, M1 rifles, and a bazooka. Among the veterans are Phillip Isham (on the roof, straddling the machine gun) and Emil Sadlon (in the back, standing with the flag). (ASBLFL.)

BELLE ROBINSON. Not all of the war effort involved fighting. Belle Robinson (left) and Jean Copp (right) worked for the Federal Bureau of Investigation as a Morse code radio operator during World War II. She made trips to New Haven, Connecticut; Portland, Oregon; San Francisco, California; and Washington, DC, where she monitored clandestine enemy communications. (Courtesy Belle Robinson.)

BARBERING SKILLS. Russell Inzinga (center) practices his barbering skills on several WACs with shampoo and hair sets aboard the ship *Edmund B. Alexander*. The men were on their way to France during World War II. The women seemed pleased to be so accommodated and rather surprised to find this service aboard ship. (Courtesy Russell Inzinga.)

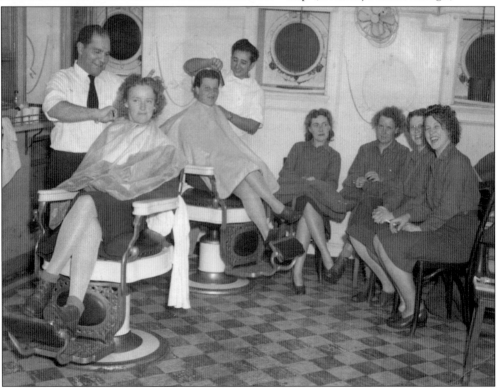

Eight

ORGANIZED SPORTS AND SOCIAL ACTIVITIES

One of the most popular sports in Columbia, and indeed in the nation today, is baseball. It has been played in town since close to its beginnings in the 1870s. Early baseball games in Columbia were played on the town green. Home plate was located near Collins Garage, and center field was toward the Congregational Church. Dr. Julian LaPierre laid out the field and organized Columbia's first team. Other nearby towns formed teams, organized leagues, and set up inter-town schedules. Families made picnic lunches, spread blankets on the grass, and enjoyed the games—much the same as it is done today. Another popular sporting activity was canoe and kayak racing. The Columbia Canoe Club was started by Pat Murphy in 1961. It went on to achieve national and worldwide recognition. The club hosted several national events on Columbia Lake. Other popular sports activities have included sailing, archery, and skiing. The Columbia Recreation Council was organized in 1946 and offered many programs. There were dances for teenagers and young adults, several aquatic activities including swimming lessons and a girls' synchronized swimming group called the Aquacades, beauty contests, gymnastics, basketball, hockey, and bowling. Adult programs included art classes, swimming lessons, and hobby shows. The council also sponsored a Memorial Day service, a Fourth of July parade, and a Christmas carol sing, the latter two of which are now part of the Lions Club programs.

Dr. Julian LaPierre. LaPierre laid out the first baseball diamond on the Columbia town green in the 1870s. He also organized the first baseball team in Columbia, managed it, and even acted as umpire. A careful examination of the photograph on pages 20 and 21 shows early baseball players on the green. In one game, Herb Post hit a ball over the church roof. (CHS.)

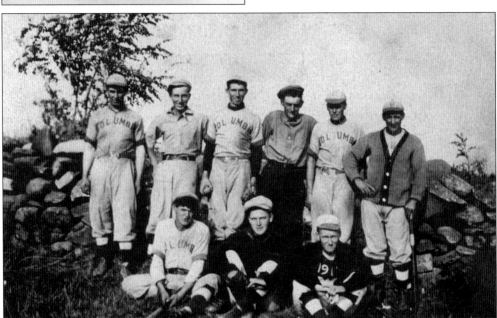

Columbia's 1916 Baseball Team. Baseball has been a tradition in Columbia since after the Civil War. Gloves were not used, and fielders could get a batter out by either catching a ball on the fly or the first bounce. The 1916 team members pictured are, from left to right, (first row) Raymond Squier, Llewelyn Latham, and Horace Little; (second row) Roland Cobb, Phillip Isham, Robert Cobb, William Friedrich, Herbert Collins, and Edward La Bonte. (CHS.)

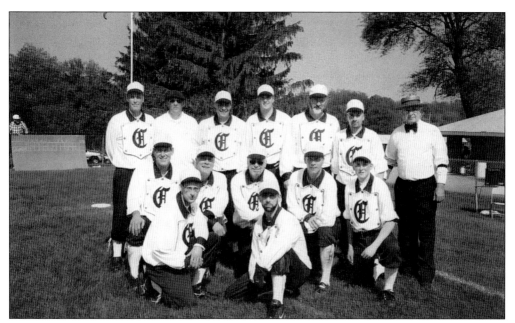

COLUMBIA CRANKS, 2004. This old-time baseball team was formed during Columbia's bicentennial. Team members are, from left to right, (first row) Christopher DelMastro and Jason DelMastro; (second row) Ronald Wikholm, Keith Curry, William McConaughy, Steven Everette, and Brian Wade; (third row) Alan Wade, Manager George Skinner, William Bright, Scott Vezina, Frank Giovannini, Peter Ganci, and umpire David Grzytch. (ASBLFL.)

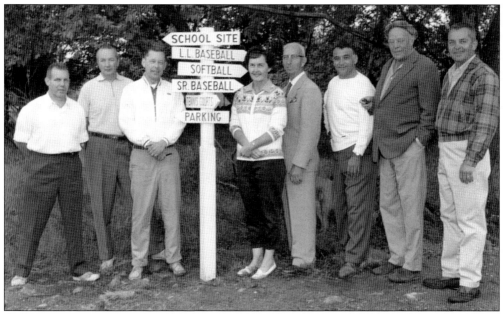

COLUMBIA BASEBALL FIELDS. After the town center was built up and baseball could no longer be played there, several fields were established around town. Firemen's Field, Katzman's Corner Field, and Hutchins' Field were a few. In 1972, the town built the Recreation Park and established three baseball fields. Recreation Council officials pose with a sign pointing the way to the new fields. (ASBLFL.)

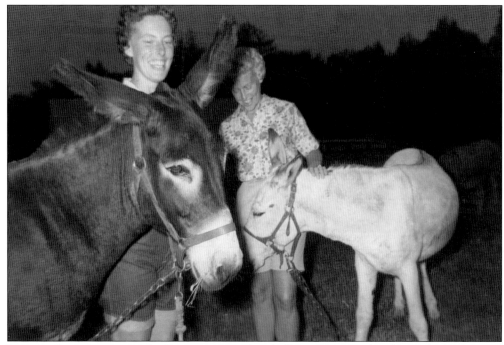

DONKEY BASEBALL, C. 1959. In many cases, baseball games were played strictly for fun and entertainment. Here, two ladies, Nancy Nuhfer (left) and Velva Lennox, prepare donkeys for a game against the men. At times, the donkeys were very cantankerous; controlling them was more of a challenge than playing the game. (CHS.)

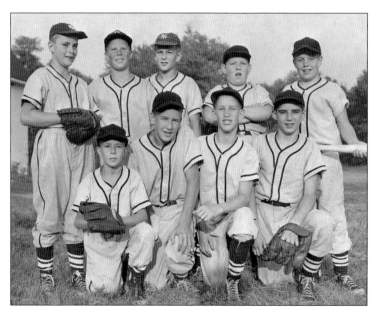

JUNIOR DIVISION BASEBALL CHAMPS. Baseball in Columbia has been played at many age levels. These Columbia youth won the Junior Division Championship of 1953. The team members are, from left to right, (first row) Brian Sinder, Louis Sorrachi, Ronald Cobb, and Francis Baker; (second row) William Macht, John Wheaton, Enn Koiva, Leonard King, and Thomas Collins. (CHS.)

PAT MURPHY. Pat Murphy founded the Columbia Canoe Club in 1961. She spent eight to ten hours a day teaching paddling basics and the techniques of canoe and kayak racing to her students. Her standards were strict. Students would have to execute up to 500 paddle strokes while sitting at the dock before getting into their canoe or kayak. (ASBLFL.)

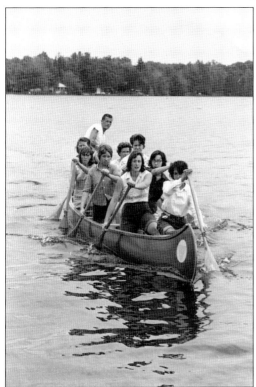

CANOE CLUB MEMBERS. The Columbia Canoe Club hosted several national races at Columbia Lake starting in 1964. Members of the club practice with Sterling Brightman (rear), Pat Murphy (in front of Sterling, to his right), and Mary Fletcher (in front of Sterling, to his left). The club won the President's Cup in Washington, DC, in 1963. (CHS.)

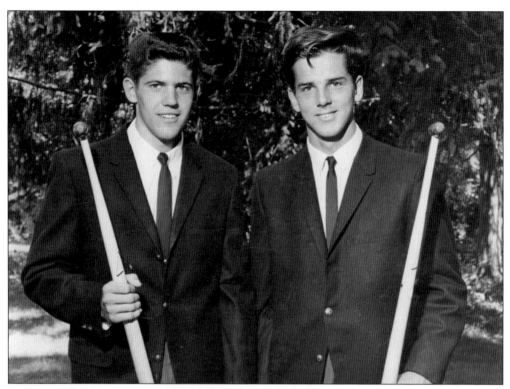

WORLD RECOGNITION.
Columbia Canoe Club
members Robert Fletcher
(left) and Dennis Murphy
are in their traveling suits,
getting ready to attend
the International Regatta
in Berlin, Germany. Both
represented the United States
in the 1966 International
Canoe Club Championships
in East Germany. (CHS.)

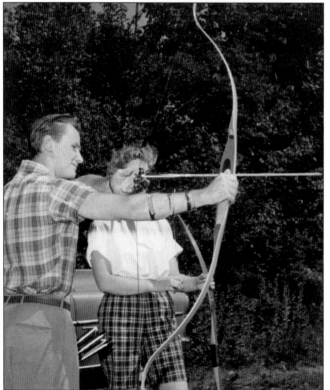

ARCHERY. Arthur Hall gives
an archery lesson to a young
lady. Hall introduced the
sport in Columbia in the
1950s. Lessons were initially
taught to archers at Dr. Ralph
Wolmer's yard on Lake Road
and later at Max Lessenger's
property at Mono Pond.
The club built a 25-target
course and a clubhouse on
the property. (ASBLFL.)

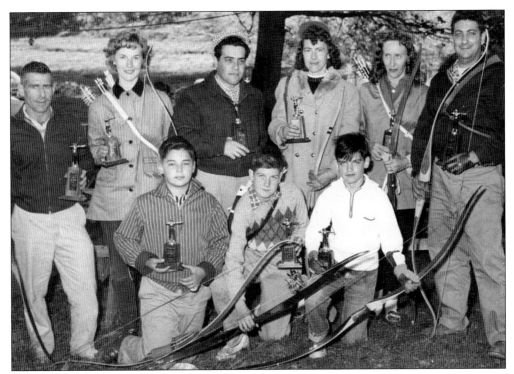

ARCHERY COMPETITION, c. 1958. Members of the Columbia Archery Club participated in many competitive matches. In this photograph, men, women, and youngsters receive trophies in their respective classes. In later years, Arthur Hall opened his own successful archery business. (ASBLFL.)

Order of Technique		
REQUIREMENTS	APPROVED	DATE
Use of poles		
Walking		
Kick turn		
Side step		
Herringbone		
Traverse-kick-turn		
Snow plow		
Snow plow turn		
Slow stem turn		
Fast stem turn		
Stem christie		
Schwingen		
Parallel christie		
Pure (stop) christie		
Slalom		
Jump turn		
Terrain jump		
Trail running		
O K for 4th class test		
O K for 3rd class test		
O K for 2nd class test		
Passed 4th class test		
Passed 3rd class test		
Passed 2nd class test		

SKI CLUB MEMBER PROGRESS REPORT. The Columbia Recreation Council organized a ski club in the 1950s. It was quite active for many years. Each member of the ski club was required to qualify in several categories when learning to ski. The progression to expert slopes required proficiency in all categories. (ASBLFL.)

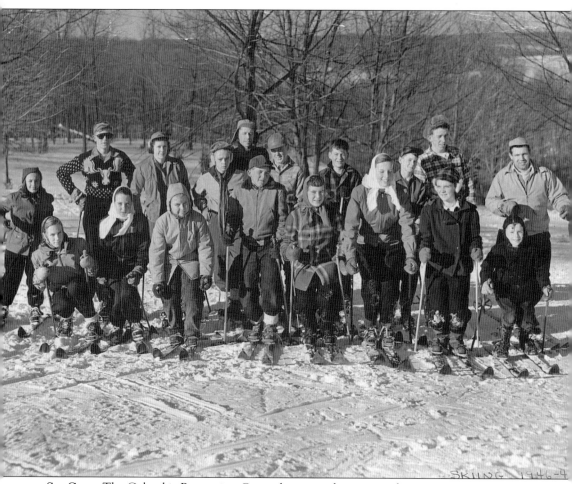

SKI CLUB. The Columbia Recreation Council organized a variety of sporting activities in town. Members of the Columbia Ski Club ready for action are, from left to right, (first row) Caroline Petroquin, unidentified, Richard Young, unidentified, Betty Bernet, Nancy Nuhfer, Gwen Bronson, and Douglas Wolmer; (second row) Nancy Woodward, Wallace Lohr, Leona Wolmer, Richard Davis, Ralph Wolmer, Herbert Englert, Dean Tibbits, Victor Wolmer, Ernest Payne, and Wilber Fletcher. The ski area appears to be on top of Utley Hill, with Columbia Lake in the background. Note the openness of the area, with no homes nearby. The group consisted of younger boys and girls as well as adults. There were no ski lifts, so plenty of energy was required to get to the top. (ASBLFL.)

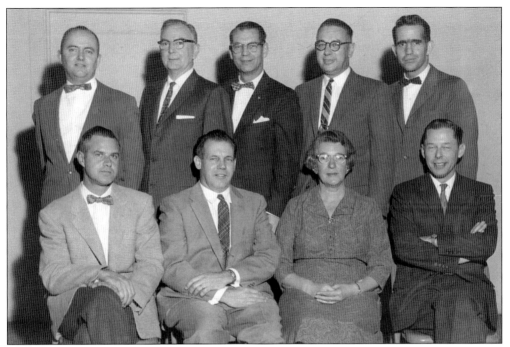

COLUMBIA RECREATION COUNCIL. The council was formed in 1946 to promote leisure-time activities for youth and adults. The first nine chairmen of the organization are, from left to right, (first row) Jack Card, Wilbur Fletcher, Eleanor Tuttle, and Ralph Wolmer; (second row) Charles Randall, Howard Thayer, Maurice Clark, Joseph Lusky, and Carl Gosline. (CHS.)

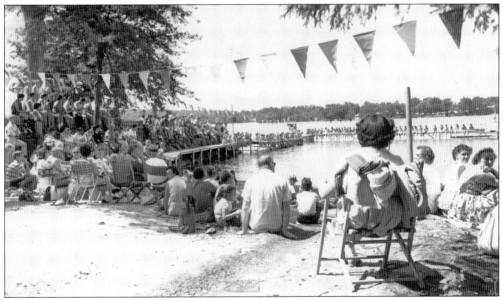

SWIMMING PERFORMANCE, C. 1957. Huge audiences attended the swimming performance programs at the town beach. Many spectators brought their beach chairs along to spend the afternoon watching the boys and girls display their newly acquired skills. Note the old wooden dock, a relic of the past, and children sitting along the dock waiting for their turn to impress their parents and friends. (ASBLFL.)

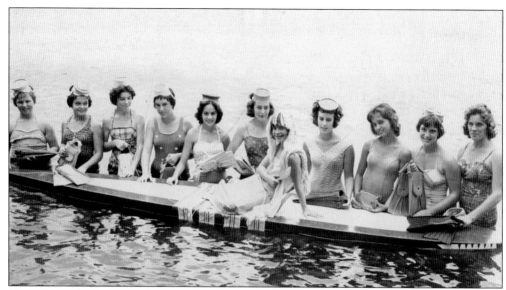

COLUMBIA AQUACADES. This group of synchronized precision swimmers performed at many Columbia Recreation Council summer programs at the lake. Shown are, from left to right, Joanne Gadoury, Sally Card, Dayna Thompson, Karen Hirn, Cheryl Berkowitz, Lee German, Karen Wolmer, Nancy Bartolan, Pamela Lusky, unidentified, and Andrea Stimpson. (ASBLFL.)

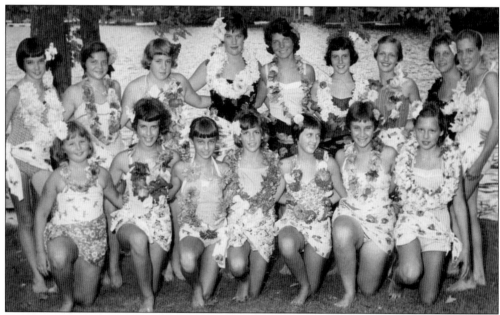

HAWAIIAN WATER BALLET. These Columbia ballet swimmers take time out to pose for a photograph. Pictured are, from left to right, (first row) Joanne Gadoury, unidentified, Pamela Lusky, unidentified, Judy Hills, Eileen Alexander, and Sally Hutchins; (second row) Dayna Thompson, Sally Card, Linda Collins, Patricia Murphy, Dianne Sanden, Donna Rosen, two unidentified, and Andrea Stimpson. (ASBLFL.)

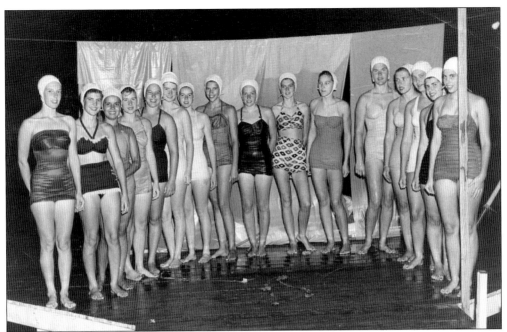

CALENDAR GIRLS, C. 1950. These beautiful Columbia girls pose for a photograph. Shown are, from left to right, Nancy Nuhfer, Joanne Armstrong, Dorothy Jensen, Betty Burnett, Lillian Banner, Ann Hennricks, Claudia Ethridge, Betty Falk, Betty Trotter, Gwen Tibbits, June Squier, unidentified, Barbara Silverstein, Judy Jackson, Phyllis Silverstein, and Sheila Panos. (ASBLFL.)

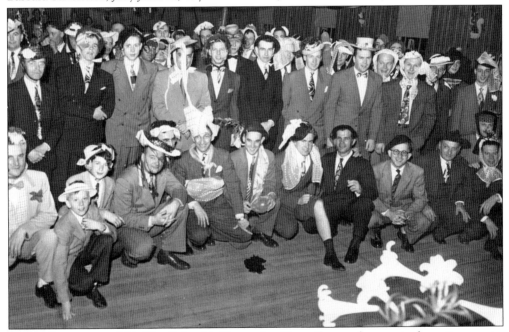

SPRING FORMAL, C. 1950. The Columbia Recreation Council not only organized sporting events, but also sponsored a formal dance every spring. Here, young men display their fancy hats in a competitive rivalry. Perhaps the winner of this event got a chance to dance with his choice of young ladies. (ASBLFL.)

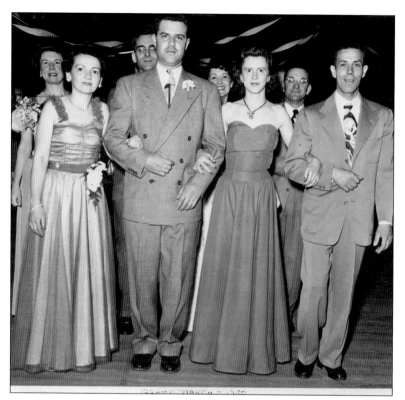

FORMAL DANCE. Young men and women in formal attire participate in the spring dance sponsored by the Columbia Recreation Council. Rock and roll, in its infancy in the early 1950s, was soon accepted and enjoyed by the young. (ASBLFL.)

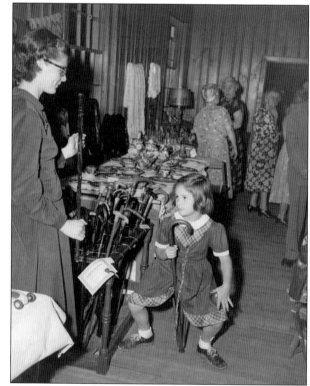

HOBBY SHOW, C. 1949. Columbia residents display some of their many interesting and varied hobbies and collections at an exhibit sponsored by the Recreation Council. A young lady finds an interesting seat at the hobby show. She has many to choose from. (ASBLFL.)

Nine

FRATERNAL AND CIVIC ORGANIZATIONS

Charitable fraternal and civic organizations have provided social, economic, and political benefits to Columbia. The Masons were the first fraternal group to organize in Columbia, forming Lyon Lodge No. 105 in 1868. David Buell was the first master of the lodge, which had 37 charter members. They initially met in Bascom Hall at the Old Inn and later at the old Porter Store, near the center of town. The Masons founded and still support many charities, including 22 children's hospitals nationwide and facilities that care for the elderly. The Columbia Grange No. 131 was the second fraternal group in Columbia. Charles Reed was the first master of this group, which was chartered in 1892. The 35 charter members also met in Bascom Hall until 1900, and then in Yeomans Hall. The grange supported the farming community with educational programs and youth farming activities and was active in lobbying in Washington to promote agricultural interests. The Columbia Lions Club was founded in 1955 with 22 charter members. William S. Burnham was the first president. Meetings were held at the Ox Yoke Restaurant in Columbia and later at the Log Cabin Restaurant in Lebanon, where the club still meets today. The Lions Club, nationally recognized for its eye health-care programs, is also well known in Columbia for its numerous community projects. The Knights of Columbus Roman Catholic fraternal organization was chartered in Columbia as No. 6305 in 1974. There were 23 charter members. The organization met at St. Columba Church. The Knights support the pro-life Culture of Life charity and provide relief aid to victims of disasters. Other civic organizations covered in this chapter are the Boy Scouts, Girl Scouts, Columbia Historical Society, and Joshua's Trust Land Conservancy. Although several of the local fraternal organizations are no longer present in the town, the history and contributions of each are a gentle reminder of past contributions that are still felt today in many different ways.

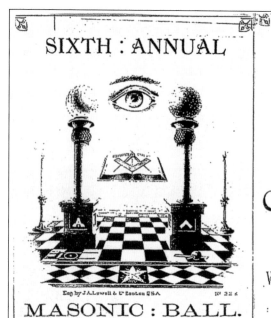

SIXTH : ANNUAL

MASONIC : BALL.

: 1885 :

Eng by J.A.Lowell & C.º Boston USA Nº 22 6

LYON · LODGE NO. 105

A. F. AND A. M.

OF : COLUMBIA : CONN.

WILL : GIVE : A

GRAND : MASONIC

Calico : Dress : Ball

AT : BASCOM'S : HALL

WEDNESDAY : EVENING, : JAN. : 28.

: YOUR : COMPANY : WITH : LADIES : IS : SOLICITED :

MASONIC FRATERNAL ORGANIZATION. Columbia's Lyon Lodge No. 105 was chartered in 1868 with 37 members. David Buell was the first master. The group held square dances at the Old Inn ballroom, Bascom Hall. An 1885 square dance program called Calico Dance Card is seen here. Note the phrase "Your Company With Ladies is Solicited." The price of the dance and supper was $1.50. (ASBLFL.)

SECOND GRANGE MASTER. The second group to organize in town was Columbia Grange No. 131, chartered in 1892. Charles Reed was the first master of the Grange, which had 35 charter members. William A. Collins Jr. (pictured) was the second master. Programs included social interaction to provide a relief to farmers from the physical and mental demands of their occupation. (CHS.)

AMELIA FULLER, C. 1893. Fuller, shown here in her lovely dress, was the first secretary of Columbia Grange No. 131. Meetings of the Grange were held in the Old Inn until 1895, when the members decided to meet in the old Masonic Hall. The building, the former home of Myrtle Collins, no longer stands. (CHS.)

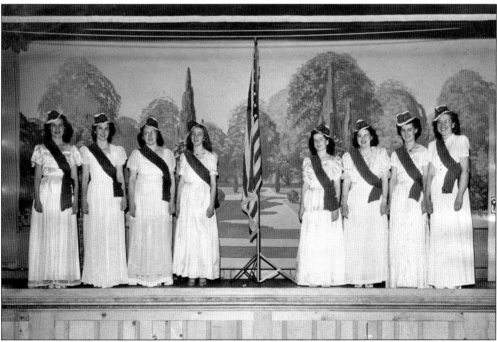

COLUMBIA GRANGE DRILL TEAM. These eight young Columbia ladies, Grange members, participate in a ceremony at Yeomans Hall. The dresses, hats, and shawls are part of the required attire. (ASBLFL.)

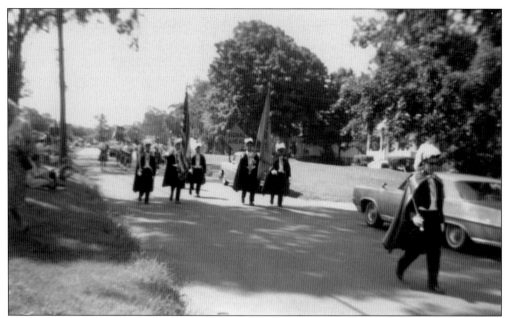

KNIGHTS OF COLUMBUS. The Knights of Columbus march in Columbia's Fourth of July Parade. The town's Knights of Columbus order, No. 6305, originated in October 1971 with 26 charter members. The organization met at St. Columba Church on Monday and Thursday nights. There are four other councils in the nearby towns of Hebron, East Hampton, Moodus, and Portland. (Courtesy Merton Wolff.)

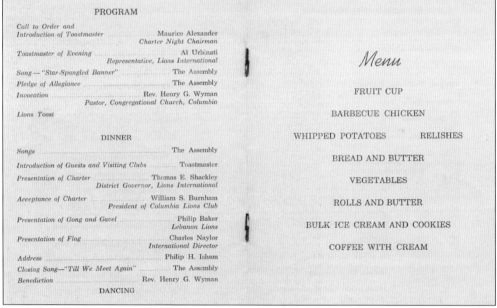

COLUMBIA LIONS CLUB. The Columbia Lions is perhaps the most recognized of all organizations in town because of its numerous community contributions. The club was organized in 1955 as an offshoot of the Willimantic Lions. An original program for a charter recognition celebration is shown, listing the newly elected officers, original charter members, board of directors, and the program for the evening. (Courtesy Columbia Lions Club.)

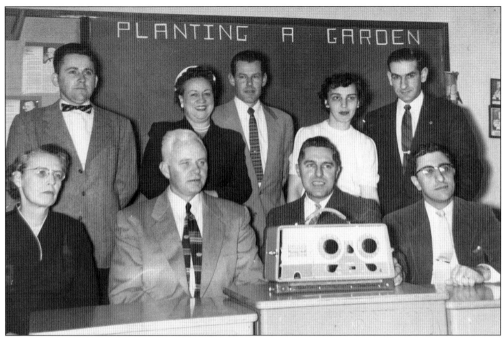

GOOD DEED. The first project of the Columbia Lions Club was its contribution of an audiometer (hearing evaluator) to the Horace W. Porter School. Posing with the device are, from left to right, (first row) unidentified, school board chairman Donald Tuttle, first president of the Columbia Lions William Burnham, and school principal George Patros; (second row) George Peters, Mrs. Paul Merrick, Walter Card, Mrs. George Peters, and Gene Dente. (Courtesy Columbia Lions Club.)

BEACH HOUSE PLAQUE. Another Lions Club project, initiated in 1957, involved the building of a new beach house on Columbia Lake to replace the obsolete structures. First Selectman Clair Robinson presents a plaque to commemorate the building. Pictured are, from left to right, Robinson, Selectman Phillip Isham, and Lions members George Smith and Prescott Hodges. (Courtesy Columbia Lions Club.)

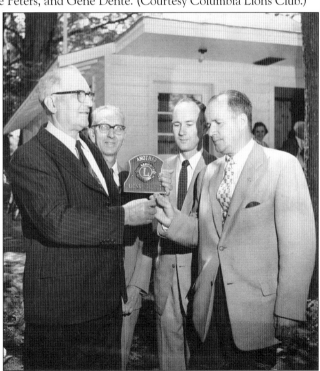

123

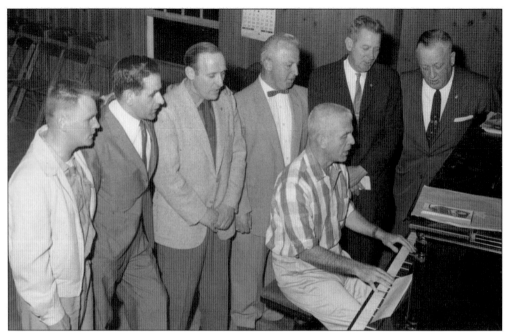

MINSTREL SHOW REHEARSAL. John McVeigh, at the piano, practices a song with fellow Lions for the yearly minstrel show. Standing behind McVeigh are, from left to right, Kenneth Erickson, Gene Dente, Morris Alexander, Morris Kaplan, Charles Olson, and Howard Bates. (Courtesy Columbia Lions Club.)

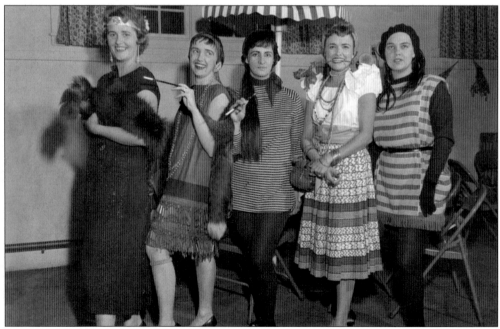

LIONS LADIES NIGHT. It was not only the men who enjoyed the Lions programs. Here, several ladies dressed in costumes are enjoying an evening program at Yeomans Hall. Pictured are, from left to right, Judy Quimby, Sandra Lohr, Helen Laramie, Lorraine Lewis, and Betty Hill. All enjoyed an evening of dancing, laughter, and gourmet food. (Courtesy Columbia Lions Club.)

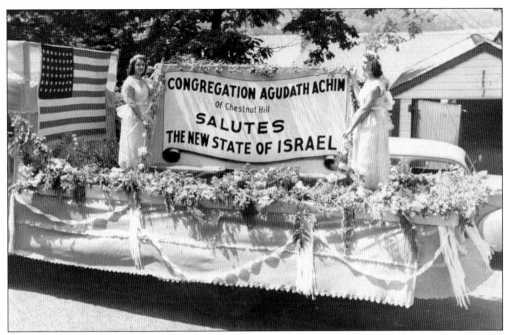

OTHER LIONS PROJECTS. The Columbia Lions Club has provided the town with many community amenities, including the town gazebo, the veterans memorial, and the Firemen's Field. In addition, the Lions co-sponsor the Fourth of July Parade. Shown here is a float from one of the earliest parades sponsored by the Lions. (ASBLFL.)

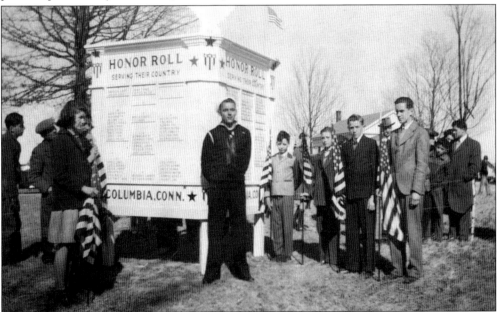

COLUMBIA BOY SCOUTS. Scouting in Columbia started in December 1942, when the Parent Teacher Organization accepted a charter for Boy Scout Troop 62. The first scoutmaster was Reginald Lewis, followed by E. Malcolm Stannard and Wilbur Fletcher. Shown at the COGS Honor Roll dedication are three Boy Scouts dressed in suits for the occasion, with Gus Naumec (center, in Navy uniform) and Guy Beck (far right). (Courtesy Merton Wolff.)

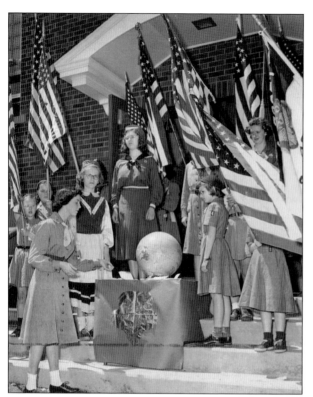

COLUMBIA GIRL SCOUTS. This Girl Scout flag ceremony at the Horace W. Porter School was in commemoration of Girl Scouts all over the world. Here, scouts are dressed in Brownie, Cadette, Junior, Mariner, and foreign nation uniforms. Note the Girl Scout trefoil logo on the table holding the globe, as well as the Girl Scout flag to the far right. (ASBLFL.)

BROWNIES IN PARADE, C. 1950. The first Girl Scout troop in Columbia was established in 1938, sponsored by the Ladies Aid Society. The troop leader was Leona M. Wolmer, with assistants Lois E. Clarke, Beula M. Collins, Jean L. Natsch, and Brownie Hopkins. Here, Brownies ride in a decorated 1950s Crosley station wagon in the Fourth of July Parade. (ASBLFL.)

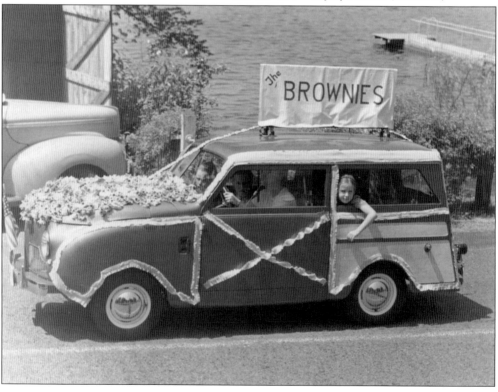

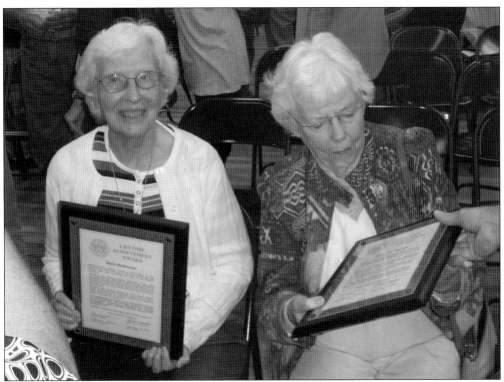

COLUMBIA HISTORICAL SOCIETY. In 1966, the Horace W. Porter School Board of Education recommended the creation of a historical society. A committee was formed, and the society gathered 112 charter members. The first officers were Edith C. Haver (president), Donald R. Tuttle (vice president), Gladys Rice (secretary), and Philip H. Isham (treasurer). On September 14, 2012, past presidents Arlene Gray, Albert Gray, and Belle Robinson, as well as town historian De Ramm, were honored with Lifetime Achievement Awards for their many years of service in preserving and promoting Columbia's history. Belle Robinson and De Ramm are seen here receiving congratulations. (Courtesy John Allen.)

JOSHUA TRUST. The Joshua Trust, initiated in 1966, owns over 1,000 acres of preservation land. The 118-acre Utley Hill Preserve, Clarke House farmland, and Potter Meadow area in Columbia are part of the conservation land. Shown here on a tour of the Utley Hill area are longtime member Albert Gray (second from left) and his wife, Arlene Gray (fourth from left). (ASBLFL.)

Discover Thousands of Local History Books
Featuring Millions of Vintage Images

Arcadia Publishing, the leading local history publisher in the United States, is committed to making history accessible and meaningful through publishing books that celebrate and preserve the heritage of America's people and places.

Find more books like this at
www.arcadiapublishing.com

Search for your hometown history, your old stomping grounds, and even your favorite sports team.